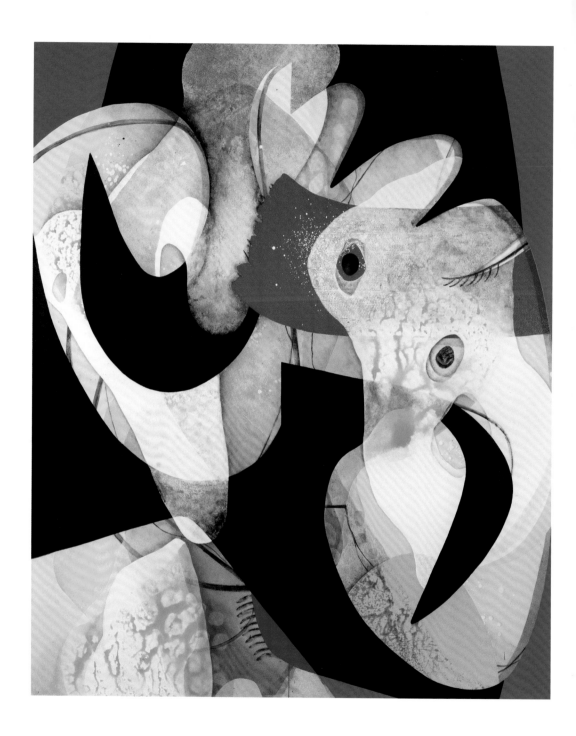

CARRIE MOYER

PIRATE JENNY

IAN BERRY

ESSAY BY
BARRY SCHWABSKY

THE FRANCES YOUNG TANG
TEACHING MUSEUM AND ART GALLERY
SKIDMORE COLLEGE

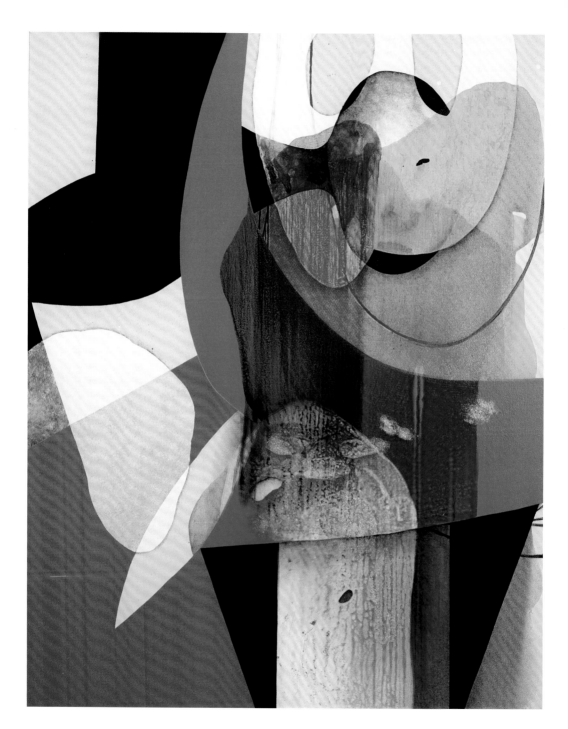

SENSATION ZONE

A DIALOGUE WITH
CARRIE MOYER
BY
IAN BERRY

FOR THE PAST TWO DECADES, New York-based artist Carrie Moyer (b.1960) has created paintings that boldly combine abstraction, political imagery, and unapologetic visual pleasure. Influenced by her background in graphic design, feminism, and queer activism, Moyer's paintings intricately interweave concept, research, and experience. Moyer loads her complex and seductive works with a range of stylistic and physical references to Color Field and Surrealist paintings, Synthetic Cubism, ethnographic objects, and biomorphic forms.

Ian Berry: Where did you grow up?

Carrie Moyer: All over the place. I went to fifteen different schools before I graduated from high school. My parents were part of the hippie generation. I'm not sure they thought of themselves that way. For them it was more like a very long search for a fulfilling lifestyle.

I was born in Detroit, Michigan. When I was nine my parents moved us in a Bell Telephone van to Berkeley, California—it was my sister and me, our dog Bob, and all of our belongings. Between ages nine and seventeen I went to many, many schools and lived all over northern California, Oregon and Washington State.

IB Did growing up that way give you a sense that you could live an independent artist's life, or was becoming an artist a way to get away from that kind of life?

(previous spread)
Hook, Line & Sinker, 2012
Acrylic, graphite on canvas
72 x 60 inches
Private Collection

(facing)
Carnivalesque, 2012
Acrylic, glitter, graphite on canvas
60 x 48 inches
Courtesy of the artist and CANADA

*Everything for
Everybody*, 2001
Acrylic, glitter on linen
68 x 58 inches
Collection of the artist

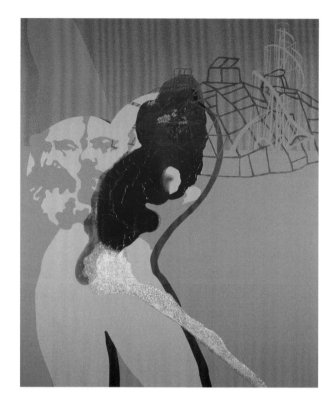

CM My parents always encouraged my sister and me to be independent.
However, it's even more scripted because my mother wanted us to be
artists since we were children. When we were very little we had an
art room in our house. My parents would sleep in the living room, my
sister and I shared a bedroom, and the other bedroom was for art
making. Practically speaking, the setup was a result of my parents
sleeping on a foldout couch, and the "extra" room became our art room.
But even though I was interested in art and was always making things,
my first love was dance.

IB What about less direct influences from that time?

CM I had a whole inner life based on reading books and magazines. My
parents were really good about taking us to see museums, concerts and
cultural events. I have very distinct memories of seeing Diego Rivera's
incredible fresco murals at the Detroit Institute of Art. But I wasn't
only interested in art; I was also really interested in fashion, design and
music. I knew when I was about ten that I would move to New York.

IB You remember having that idea?

CM I don't remember exactly, but I very willfully did certain things that
signaled that desire. For instance, I didn't learn how to drive, even

though learning how to drive is a rite of passage for any teenager living in a small town in Oregon. You've got to get away from your parents and driving means freedom. For me it was "I'm going to New York where I don't need to know how to drive."

IB Did you have any images of what an artist's life was like?

CM Yes. I had read all sorts of books that took place in Greenwich Village and knew that's where artists lived. In my teens, my idol was Patti Smith. I was fifteen and living in Corvallis, Oregon, when her album *Horses* came out. Along with David Bowie, she became my androgynous ideal, especially Mapplethorpe's picture of her on the album cover. An artist's life became punks, Patti, and this kind of glamorous, grungy world of tenements and staying up all night. It was all very sexy to me. New York was the place where life got going after ten pm.

IB When did you get to New York?

CM 1979.

IB For school?

CM I went to Bennington College first, where I got a full scholarship to study modern dance. In 1978 my mother took me on a Greyhound bus from Oregon to school in Bennington, Vermont. We stopped in New York on the way to visit a friend, and that was the first time I'd ever been in the city. It was amazing. We went down to the Lower East Side, which was mostly Puerto Ricans and Orthodox Jews at the time, and I thought, "This is so wonderful." I had grown up in very white environments my whole life. At the end of my freshman year at Bennington I was in a serious car accident in which two friends were killed. I dropped out of school and moved to New York. I had to change gears and went straight to painting and drawing.

IB Because you weren't able dance anymore?

CM I shattered my elbow so I had no extension in one arm. Remember,

Chromafesto
(Sister Resister 1.2), 2003
Acrylic, glitter on canvas
36 x 24 inches
Private Collection,
Germany

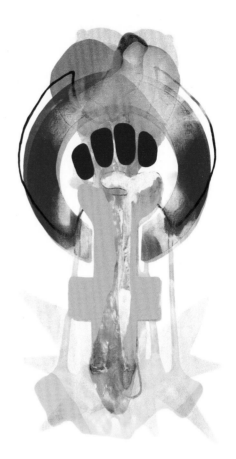

this was long before Mark Morris started using dancers with all sorts of body types in his dance pieces. So continuing to dance was out of the question, or it felt like it at least.

IB You immediately started working as an artist at nineteen?

CM I didn't know what I was going to do so I started taking classes at the Art Students League. They had these three-hour life drawing sessions that I went to regularly. Soon after I got into Pratt Institute and made my way from there. It was a confusing time because I was recovering from being badly injured and the accident had changed my outlook in such a drastic way.

IB What is the first art work that made a big impression on you?

CM I was really interested in German Expressionism and the Blaue Reiter when I was a kid. Somehow I had seen a Christian Schad painting in a book—a fact that feels totally random now that I'm a grownup. It was

so meticulous and very erotic in the way he painted it. The surface is incredible; the drawing is incredible. Of course I now know Schad was part of the Neue Sachlichkeit, working in reaction to Expressionism. I also really liked painters such as Alexej von Jawlensky and the Russian wing of Expressionism. *Portrait of Alexander Sakharoff*, his picture of a demonic looking ballet dancer of indeterminate gender in front of a bright red background—it is both graphic and sensual at the same time. I finally saw the painting in person at the Lendbachhaus in Munich and it was even better in person. My parents also had a lot of art posters around our home like Joan Miró's painting *The Farm*. I've been looking at that painting a lot lately. It's incredible.

IB Can you describe the Miró?

CM It's ostensibly a straightforward landscape with a farmhouse, a barn, and a woman in the background. There's a big tree that bisects the middle of the scene. All the objects, buildings, flora and fauna seem to have been put through Cubism and are placed in a hierarchical composition as if we're being shown an inventory of a farmyard. Everything—the rooster, the goat, the wagon, and the bucket, even the weeds—has been flattened into a set of graphic symbols. It's almost like a painting from the Middle Ages.

IB Do you think your initial start as a dancer has any relationship to what you do as a visual artist?

CM It seems odd that I haven't given much thought to the relationship of dance to my visual artwork. However, in the past few years it's becoming clearer to me as I articulate how the paintings are made as well as the forms that show up in the images. I start with a stretched, unprimed canvas, hung on the wall. On that I'll first make a very loose drawing that becomes a kind of structure to hang paint on. Then the painting is put on the floor and pouring begins. Building up the layers of transparent paint becomes a funny dance around the canvas that involves lifting and tilting the stretched canvas to get the paint to move around and become

a composition. I also think about dance in terms of what's in the picture. Right now I'm interested in this idea that dance is a collection of body parts moving around in space.

IB Who were important teachers for you at Pratt?

CM I went to Pratt for my BFA and, because Bennington did not give grades, I had virtually no transfer credits and had to start over. So I went through the entire four years at Pratt, including the Foundation year, which I really loved. A lot of my teachers were really interesting people who had been in New York for years.

I spent my time at Pratt becoming a really exuberant abstract painter. I never liked working from life. Terry Winters, Gary Stephan, Katherine Porter, Bill Jensen, Carroll Dunham and Gregory Amenoff were showing a lot and became my painting heroes—a kind of eccentric abstraction that was funny and biomorphic at the same time. My canvases were cut up and collaged à la Lee Krasner. I was trying to set connections to earlier American painters such as Arthur Dove, Marsden Hartley and artists from the Pacific Northwest such as Mark Tobey.

In art school my political consciousness really developed and came out swinging—mainly because it felt like we (the women students) were being treated as second class. One teacher who had a huge impact on me was an artist named Rudolph Baranik. He was my drawing teacher. At the time I studied with him, I didn't know that he wrote criticism and did very direct political art in addition to making abstract paintings. Those paintings referred to the Vietnam War, but the images themselves looked like surfaces of the moon or something. They are essentially black and white abstractions based on the burned bodies of children who have been hit with napalm. The pictures are really powerful. Baranik was married to May Stevens, who was very active in the Feminist Art Movement.

I was also fortunate to be an intern at *Heresies* magazine when I was in school. Jenny Snider (another beloved drawing teacher) and her sister Amy Snider both taught at Pratt. Amy arranged for my internship.

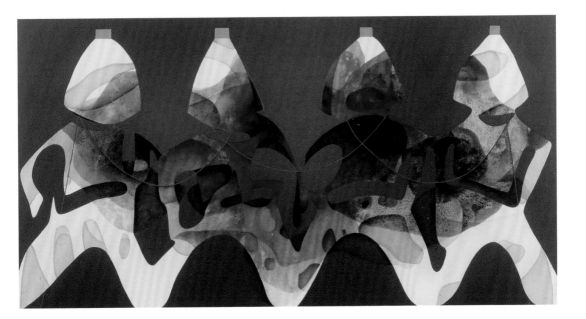

Frieze, 2009
Acrylic, glitter on canvas
45 x 71 inches
Collection of Evelyn and Salomon Sassoon, New York

As a result, I got to meet all these artists who were part of the Feminist Art Movement, something I didn't know much about at the time.

IB What was *Heresies* about?

CM *Heresies* was a magazine run by a collective of women artists and activists. Each issue was based on a different topic. It was where you got to see what other feminist artists and thinkers were doing, since none of that work made it into galleries or museums. One issue that influenced me a great deal was called "The Great Goddess." It focused on scholars and artists who were searching for and/or imagining a matriarchal prehistory. Somehow it felt urgent to find some sort of precedent or history because women artists were not included in the canon of art history at all. In my freshman art history survey our text-book was Janson's *History of Art*—we used to joke that the only woman artist included was Mary Cassatt. The artists who were part of *Heresies* opened my eyes to all the marginalized histories that hadn't yet made it to the center.

IB Have you always looked for or created a group of women artists to be with?

CM After I graduated from Pratt and stopped working at *Heresies*, I set up a studio in Williamsburg. I felt completely isolated and it was hard for me to work on my own. I had been an abstract painter for four, five years, and my newly fired-up political consciousness didn't know what to do with abstraction. I couldn't rationalize it. Also I didn't understand the need for community because I didn't grow up with a community. I grew up with my little four-person family—that was it. So I quit painting

for four or five years in search of other things. It was the mid-1980s and the art market madness was really hyped. It seemed vacuous, glitzy, and filled with huge male characters like Julian Schnabel and David Salle. I thought, "I'm never going to be a part of this world."

The way I got back into art and also gained a community was through queer activism, specifically Queer Nation and the Lesbian Avengers. What I didn't realize at the time is that activist groups are always filled with artists. So I had found an amazing community that hooked directly into my life experience.

IB When did you start working as graphic designer?

CM I graduated with a BFA in painting and virtually no other skills, no way to earn money. At one of my first jobs I was trained to do desktop publishing (as it was called at that time) because I was an artist. The new technology was really exciting. I was struggling in the studio and somehow it felt more honest to use my art school training at a "real" job. So I started working fulltime as a graphic designer. Eventually I got an MA in computer graphic design, thinking I'd go into animation.

IB What was your design work like?

CM I designed lots of things—brochures, all sorts of print advertisements, pharmaceutical packaging, Christian music catalogs. I worked on a campaign for a cigarette called Uptown that was to be marketed to black people, which got canned immediately, of course!

IB At the same time you were also using graphic design as part of your activist work and you founded Dyke Action Machine! What was the mission of that project?

CM Dyke Action Machine! is a public art project that I started with my friend, the photographer Sue Schaffner. Sue and I were both earning our living in advertising when we met in Queer Nation. It was the early nineties, and the second wave of activism was happening around queer identity and visibility, instead of AIDS. We wanted to put our design chops to work

for our own cause. So Sue and I started making posters anonymously under the name Dyke Action Machine!

Our posters were wheat-pasted all over New York City, right next to mainstream advertising. At that time there were lots of vacant lots and construction sites in New York City and the streets were covered with jazzy, eye-catching print graphics. Part of DAM!'s agenda was to make lesbians more visible to the general population in an effort to increase "tolerance." This equation between visibility and acceptance was really central to the work queer activists were doing at the time.

We were definitely influenced by Gran Fury and Barbara Kruger who hijacked the language of advertising with their own slogans and content. Suddenly there were powerful messages and images about civil rights issues pasted right next to an ad for Calvin Klein Jeans.

IB What were some of the messages?

CM Every year we did a project that was topical. So the year that Clinton announced his Don't Ask, Don't Tell policy we had a highly visible issue to work with. The policy stated that gay people could be in the military as long as they didn't tell anyone they were gay. *Straight To Hell* was an advertisement for a fake revenge movie in which three butch lesbians are kicked out of the Army and return to do bad things [laughing]. Almost everything we did riffed on classic graphic design tropes. In this case, the genre was a movie poster.

Most projects took us four months to produce. Around five thousand posters would be wheat-pasted during June, Gay Pride month in New York City. Big ad agencies hired wheat-pasting crews who could easily cover over all our posters in one night. So it was a matter of being vigilant and orchestrating the whole thing carefully.

IB How did you know if you had an effect?

CM We started doing this in the prehistoric days of the Internet, so nobody was blogging about it, liking it on Facebook, or anything like that. We were zealous about two things: 1, giving our posters away for free,

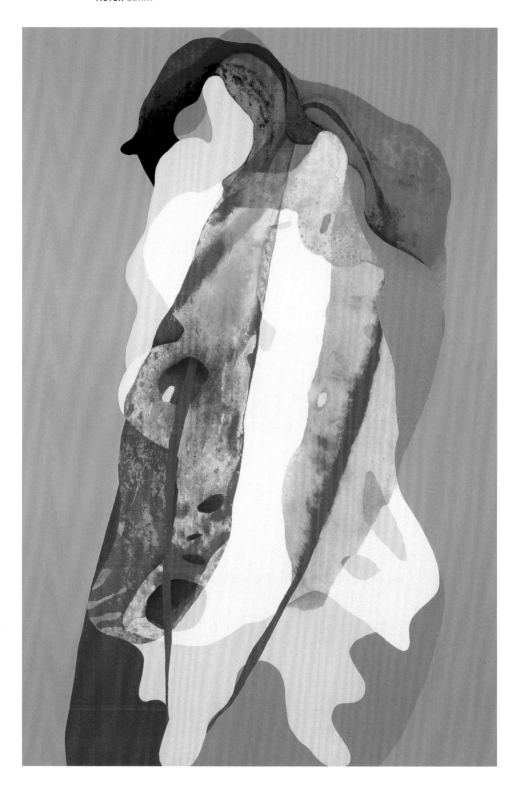

and 2, distributing them to the press, queer scholars, and activists. People collected our work. DAM! has been written about a lot and anthologized in many books on queer history and art. We were a part of a small coterie of activist art groups working at the time, including Fierce Pussy and Bureau. These were all the same people that designed your shampoo bottle and the ad for your Verizon account.

IB Were you painting at the same time?

CM Initially I had stopped because painting seemed like a bourgeois commodity and I was feeling conflicted about it. I didn't know what it was for. In retrospect, the main reason I stopped was that the art world seemed too daunting. But, after doing agitprop and activism for a few years, I started missing making things by hand, things that had a kind of tactility. The computer came to feel more like work than art. I wanted to make images about experiences that couldn't be pictured in a mediated way. Painting is really good at images that require interiority and imaginative space. So I started making these dark, funny, representational paintings loosely based on being the lesbian child of hippies.

IB And then you decided to go back to school.

CM For a while I was painting and doing agitprop at the same time. I started to show both kinds of work. In 1995 I went to Skowhegan. Afterwards I applied to the MFA program at Bard College.

IB You had already been an exhibiting artist for quite some time. Why go back to school?

CM Being at Skowhegan made me realize how much I craved dialogue with other artists. Even though New York is supposedly the art capital of the world, there doesn't seem to be much time for talking with others about what we're all doing. You're working at your day job, making art and trying to get it into shows. I don't feel that way so much anymore. At the time I wanted to have long conversations with people who were ahead

of me in both their worldview and their work. It was an amazing experience.

IB How did it change your painting?

CM It made my ideas more ambitious and larger. My whole outlook grew. The art world was in love with the idea of de-skilling at the time. At Bard, I started to go the other direction, which meant paying more attention to art history and not focusing solely on the image. Painting for me is very much about a craft that's been around for a really long time.

IB You are teacher yourself now. Does teaching affect your painting and does painting affect your teaching?

CM Teaching keeps me on my toes and makes me less lazy about my thinking. I'm constantly reading and researching artists and ideas for class and my own writing projects. And all this filters into the studio.

IB Let's talk about the craft of your paintings. When you come up with an image, what are the first steps, even before you get to the canvas?

CM I make small collages from black and white paper that turn into graphic templates for the structure of the picture. They become a kind of scaffolding for the pours and other information to hang on.

IB Do you transfer those shapes, enlarge them, and draw them out on a canvas?

CM I used to grid them out, but I don't do it anymore. I draw freehand with a very fat graphite crayon while I'm looking at the collage. This gives me the opportunity to change my mind about things.

IB Are your collages drawings?

CM Yes, basically I'm drawing with a razor on black paper and then using the cut forms to build up the image. The shapes are taped and re-taped repeatedly until I make a satisfying composition. The collages are pretty ragged and manhandled because I keep changing things. Initially I would

paint the negative or positive spaces onto the canvas; now I draw the forms directly onto the canvas. Once the outline is down, the painting goes on the floor and I'll pour very thin gesso on it. That's usually the first pass.

IB Do you keep the collage nearby when you are making these paintings?

CM I use it for the first couple of hours and then take it away so that the painting drives the process. It's important to me that you can't trace the history of its making. I want the painting to show up as this kind of inevitable gesture. I want everything to look as if it just dropped on the canvas fully formed. Because the canvas is exposed, it's possible for me to overwork a painting and then I have to get rid of it. I don't go back into them or reuse them in other ways. Maybe that will change in the future, but for now I want them to seem like they just appeared. Poof! The issue of showing one's labor is not that interesting to me.

IB After you block out some shapes, chance elements start to enter with the pour.

CM Actually there's very little chance in these paintings but I want them to look at first like they are spontaneous. I'm really interested in the history of painting. So one aspect of the work is looking back to Color Field painting and the notion of flowing paint as intuitive gesture. In other words, letting the paint do what it does naturally, that is drip. I use acrylic paint, which was developed in the 1940s—by the 1960s the technology had ushered in a whole new way of painting. If you tried to pour on raw canvas with thinned-out oil paint, you would just get an ugly oil slick. The oil essentially eats away at the canvas. In a way my paintings are a building up, a collection of signs, about painting and how we read painting.

IB There are many overlapping textures on your surfaces and glitter is a regular feature. Glitter is not for rigorous painting [laughs]. Glitter is a sign for something else, no?

CM Yes, it's a sign for My Little Pony and eleven-year-old girls!

IB How did glitter find its way into your paintings?

CM I started using glitter around 1999. I wanted the paintings to be campy and I was trying to figure out the material language of queerness. Or some signifying use of color and light. I was interested in layered sign systems based on materials, paint, and gesture. For me glitter signified disco and Sylvester, this other part of my life that seemingly didn't jive with the seriousness of a painting practice.

After many years the glitter has become an integral part of the work. Now that I've used it for more than a decade, it operates in different ways. I like the tension between rigid geometric shapes, the languid pours, and the sparkling lightweight flecks. It draws a different kind of light to the canvas. The raw canvas itself acts as one light source and there's a lot of white in pictures. The glitter sits on top of everything and is even brighter than white, causing the color below to change and shift. Glitter functions as interference; it changes the image as you walk from side to side of the picture.

IB Does the language of graphic design feed into what you are making now?

CM Graphic design is so central to my process that it's hard to imagine working without it. I'm interested in the differences between how graphic design and painting are looked at. Graphic design is about speed, efficiency, and elegance of communication. The goal is to make something both seductive and quickly absorbed. I use these strategies to draw the viewer into the painting. Once the viewer is in there, I try to slow down time with complex, layered compositions and really sensual surfaces. The design element is like the honey. Nowadays, if someone spends thirty seconds looking at your painting, you are lucky. This is how the beanbags chairs and shag carpeting operate in *Pirate Jenny*. We want the viewer to actually sit down and look. It's about getting you to pause long enough to realize that you need to slow down and really look.

*Battle of the
Scholar Rocks*, 2011
Acrylic, glitter on
canvas
40 x 60 inches
Collection of George
Singer and Gus Yero

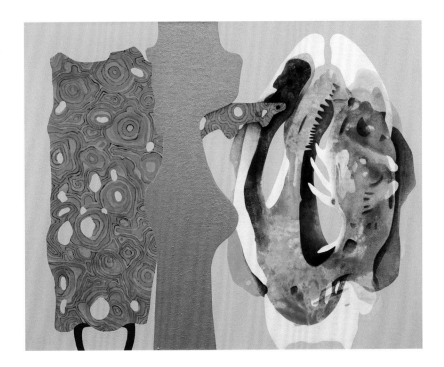

IB How is abstraction useful? Do you think painting can do work in a political way?

CM I've thought a lot about the efficacy of art and I'm constantly changing my mind on the subject. I'm not even sure this is a viable way to judge something like art. Diego Rivera's work and how he depicted the struggle for justice had a huge impact on me as a child. However I don't think a work of art can change a political situation. Art can change people individually. How art actually "works" has become much more mutable. I want my paintings to present a kind of experience that you've never had before.

In the last ten years or so I've also become active as a writer. More and more I feel like visual art and text run on two completely separate tracks. Looking back on the work I made when I returned to painting, specifically the work about lesbian children and the counterculture, I see that it needed to be representational because it was tied to language. I was overlaying texts and tropes to depict an experience, and only visual art could do that. In my current work, painting is over here and language is over there; they run parallel but they don't necessarily overlap.

IB Are you interested in provoking any specific reaction from viewers?

CM In 2007 I had a show called *The Stone Age*. I had been thinking about my own relationship with the Feminist Art Movement of the 1970s and how the practice of painting never fit somehow. Painting was completely

Flamethrower, 2010
Acrylic, glitter on
canvas
76½ x 71½ inches
The Speyer Family
Collection, New York

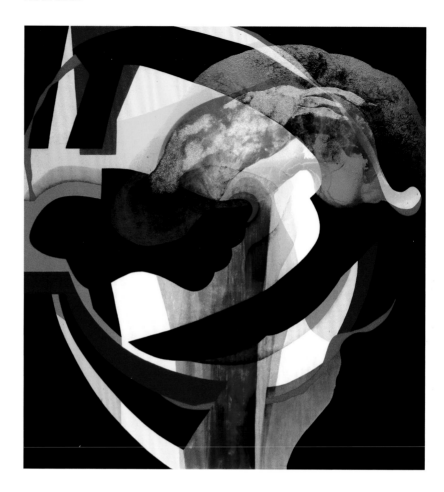

embedded in the patriarchal canon, whereas performance and video seemed way more relevant because they had virtually no historical baggage to contend with. The exhibition *WACK! Art and the Feminist Revolution* was touring the country and there was a lot of discussion around the legacy of feminist art. So I decided I would try to recuperate painting to the cause.

I wanted to figure out a kind of hybrid abstraction with forms that referred to the body. Ancient goddesses and archeology seemed like a natural place to begin. I started going to the Rockefeller Wing at the Met and looking at a lot of ancient objects like ceramics, instruments, and weapons that evoked the body, and I built the group of pictures around those forms, especially tribal objects from Oceania, Jomon pottery from Japan, and prehistoric ceramics. They became abstract icons placed in the dead center of the picture, as if the canvas was a two-dimensional vitrine. I was and still am interested in creating in the viewer a sense of formal recognition that is difficult to place.

IB How do use these forms to create something that is both abstract and recognizable?

CM With both shapes and composition. By using a cruciform or iconographic layout, I wanted the viewer to feel they were locked in and couldn't leave the canvas. There's a range of associations that emanate from a solitary form in the middle of the picture. The "Central Core" imagery invented by Miriam Shapiro and Judy Chicago in the 1970s. Propaganda. Tribal imagery. I wanted to set up a didactic tension between physical and the mental, or bodily and textural references, hoping that those meet somewhere in the viewer.

 Since that time the space in the paintings has changed a lot, even though some of those strategies remain. Now the space has opened way up and I want the viewer to feel destabilized. So in some paintings, shapes and veils of color slide in and out from all sides of the picture plane. In others, flat forms are wedged against the canvas edge, creating a little stage for painterly drama. I'm still interested in capturing pockets of space that lead nowhere and playing with the idea of depth in crazy, nonsensical illusionistic ways that showed up some abstraction from the 1960s. Blowing a big raspberry at Greenberg? There are lots of painting jokes in my work.

IB How do you respond when people see recognizable things within your abstractions, like "Hey, that's a leg, that's a rose, that's a butt"?

CM I love it. I'm interested in abstract painting that feels referential and familiar in a way that you can't exactly articulate. So you might see a foot or a body part or a hook—a combination of things that starts to generate ideas and associations in your mind.

IB Is it okay with you where we might go with that?

CM Once an artist makes something and puts it out in the world, she doesn't have any control over it anymore. Titling paintings gives me a little more control over the interpretation. I try to use titles that will create a kind of

Our Own Desires
Will Build the Revolution, 2004
Acrylic, glitter on canvas
84 x 72 inches
Collection of the artist

multivalent container around the work but it's still up to you to speculate inside that space.

It's important to me that there is beauty and a sense of discovery in my work. I have a very short attention span for art. If I see something so gripping that I'm compelled to stay and keep looking, that is a huge accomplishment. So a big part of what I'm trying to do is get people to stay. Slow down and stay with the picture. I'm really interested in the viewer, actually. And the notion of making a painting that keeps revealing itself to the viewer is pretty thrilling for me.

IB And you are interested in giving pleasure?

CM **Yes, absolutely. I'm interested in pleasure as part of the experience, absolutely.**

IB You mentioned in one of your writings that you questioned what painting is good for.

CM **Yes.**

IB So, what is painting good for?

CM **I've come to realize that the best thing about art is that it doesn't do anything at all. Everything is valued depending on its utility or lack thereof. Ideas and objects are better if they can be instrumentalized for multiple uses. These days "creativity" is seen as the magic bullet for our neoliberal malaise. For me paintings offer an alternative experience. I'm interested in painting as a kind of speculative zone, a space for sensation. To be sure, my paintings are objects for contemplation, pleasure, and beauty, and belong to the traditional art economy. But I also see painting as a form of resistance, a place to stay.**

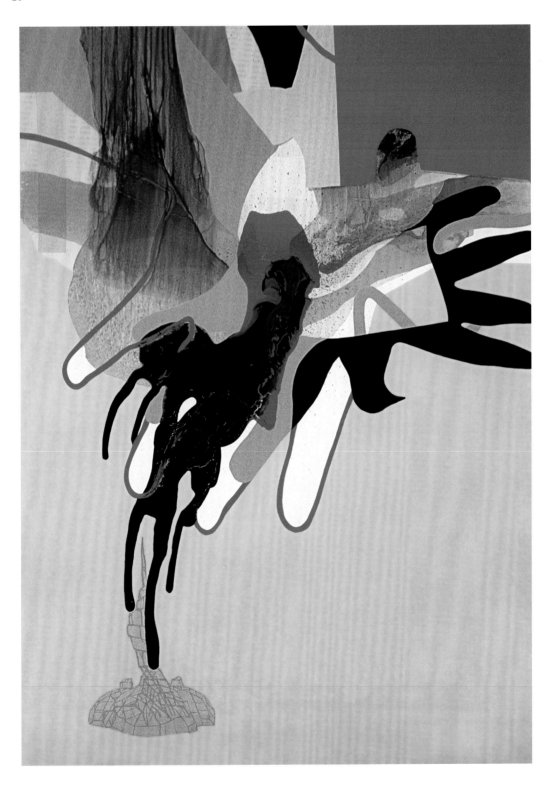

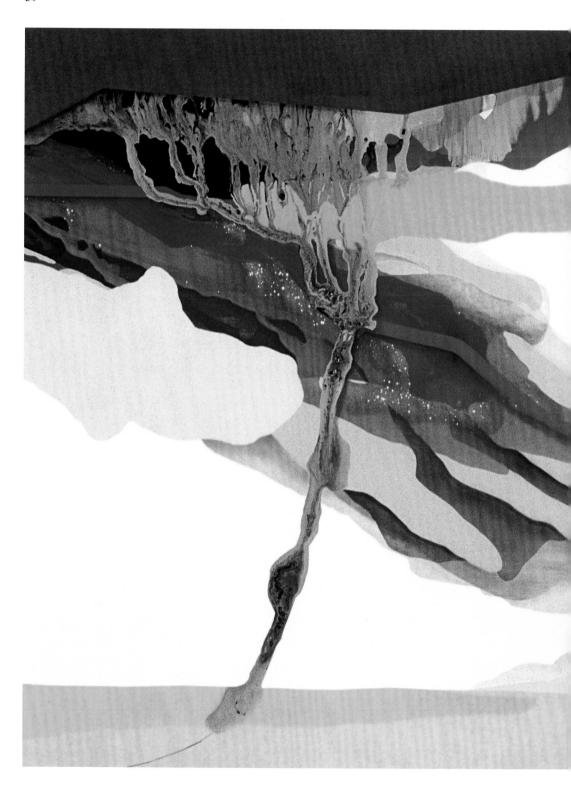

The Great Leap Forward, 2002
Acrylic, glitter on canvas
58 x 68 inches
Collection of Carlos Hausner,
New York

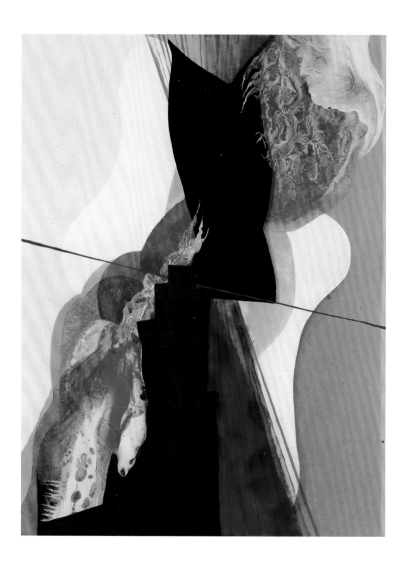

Faktura #4, 2005
Acrylic, glitter on canvas
24 x 18 inches
Collection of Stacey Fabrikant

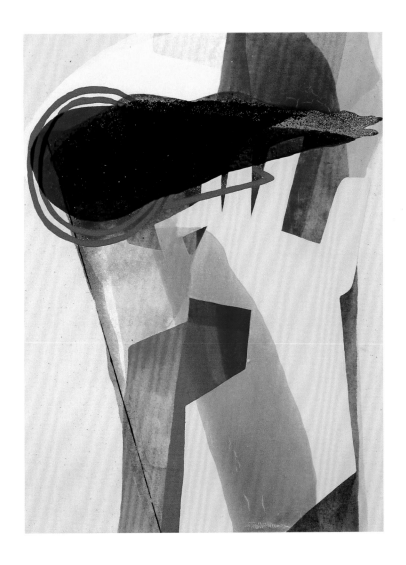

Faktura #1, 2005
Acrylic, glitter on canvas
24 x 18 inches
Collection of Stacey Fabrikant

The Stone Age, 2006
Acrylic, glitter on canvas
60 x 84 inches
Collection of Stephen Hilton

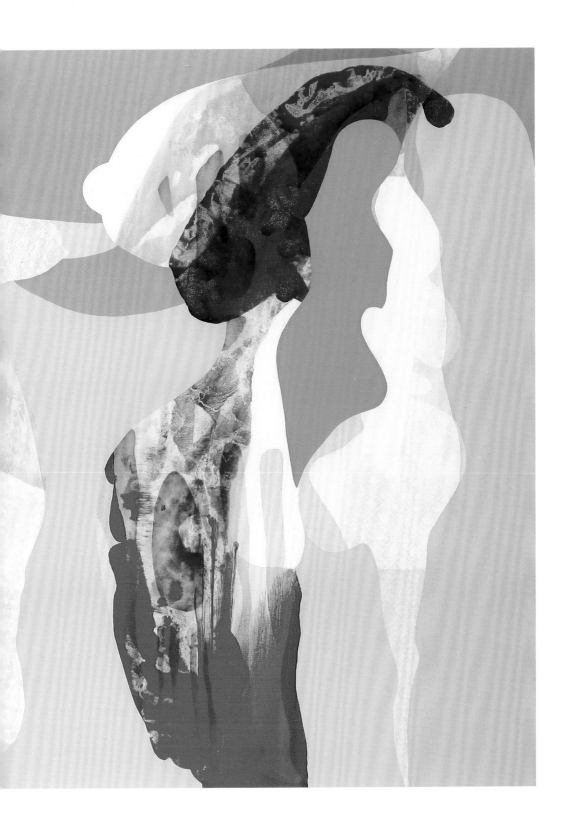

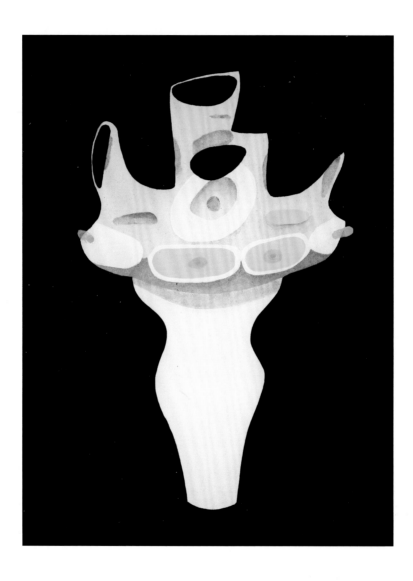

(facing)

Tiny Dancer, 2008
Acrylic, glitter on canvas
50 x 30 inches
Collection of Mary Sanger
and Kay Turner

Furbelow, 2006
Acrylic on canvas
24 x 20 inches
Private Collection

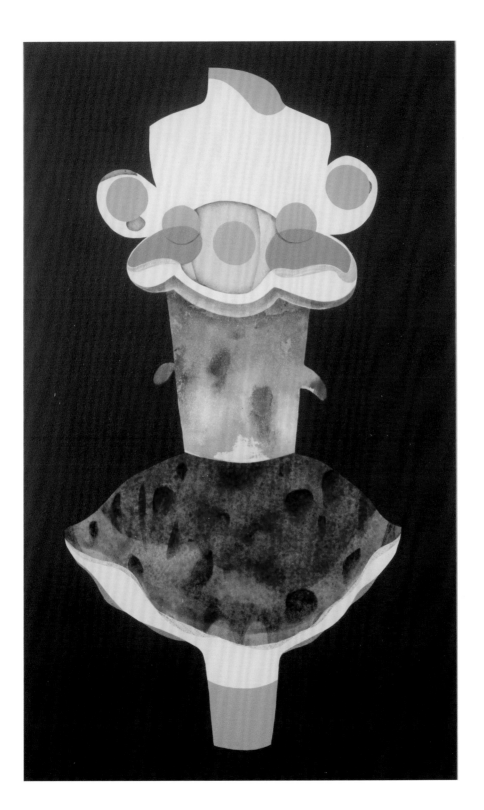

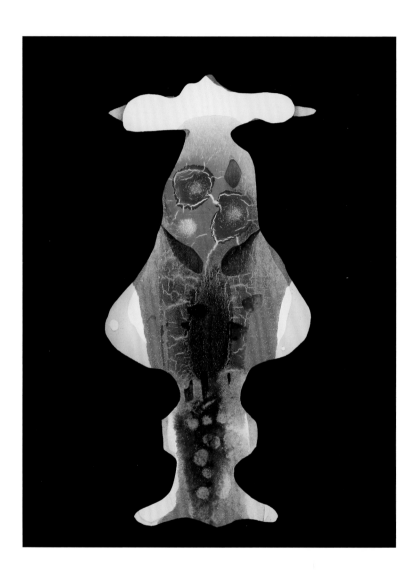

Skullspout, 2007
Acrylic, glitter on canvas
24 x 18 inches
Collection of the artist

(facing)

Sap Green, 2007
Acrylic, glitter on canvas
50 x 40 inches
(no longer extant)

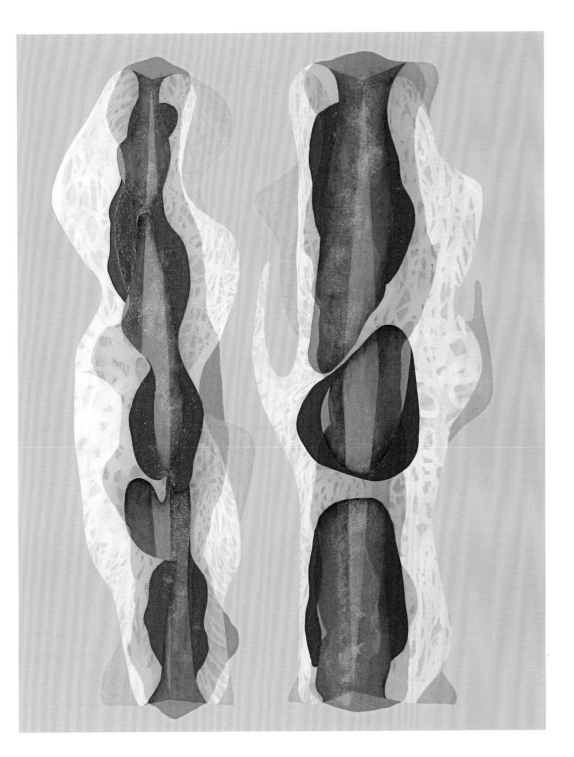

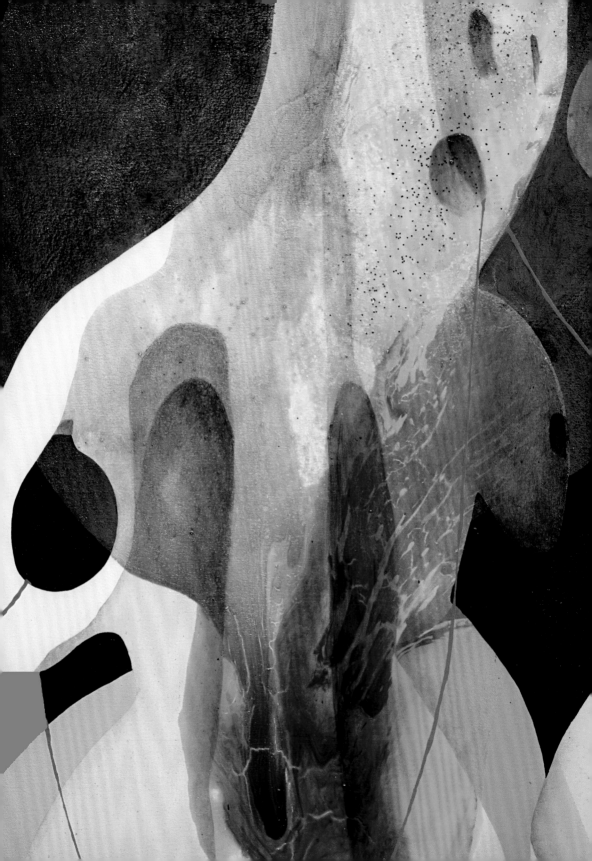

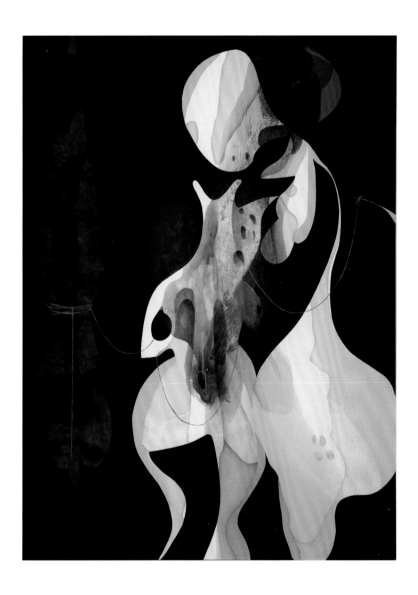

(above and detail facing)

Tableau, 2008
Acrylic, glitter on canvas
90 x 66 inches
Collection of the artist

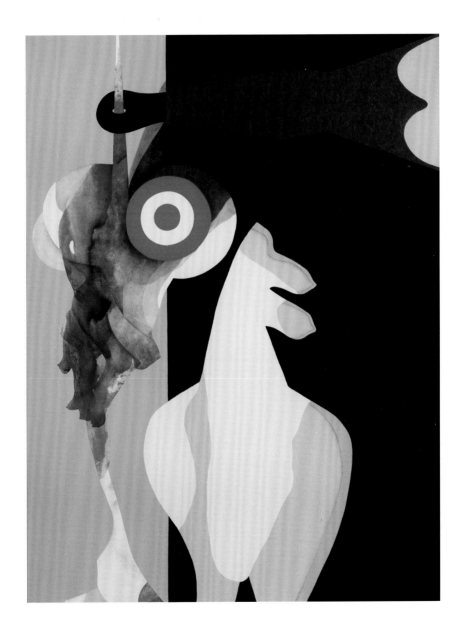

(above and detail facing)

Ballet Mécanique, 2008
Acrylic, glitter on canvas
80 x 60 inches
Collection of the artist

Rapa Nui Smashup, 2009
Acrylic, glitter on canvas
60 x 40 inches
Worcester Art Museum,
Worcester, Massachusetts,
promised gift

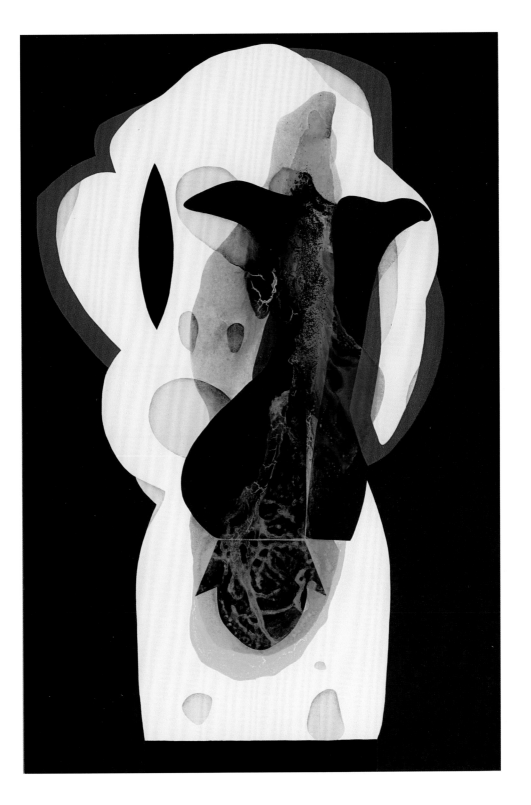

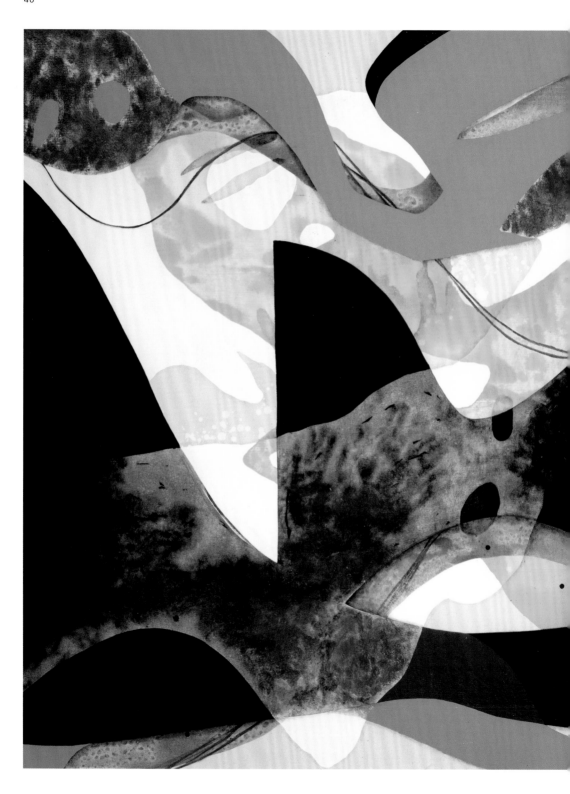

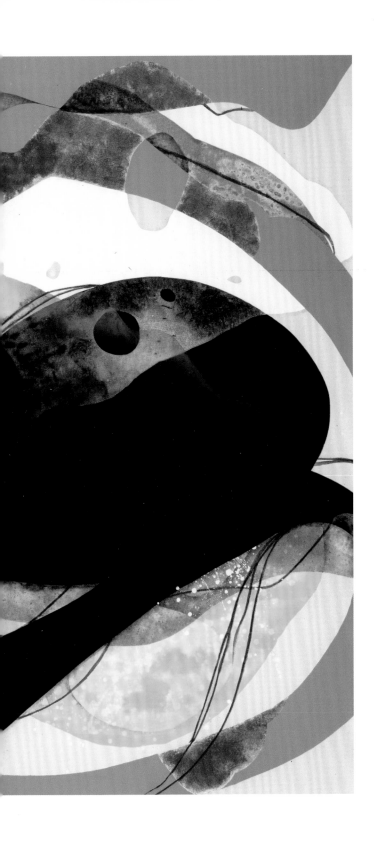

Down Underneath, 2012
Acrylic, graphite on canvas
54 x 72 inches
Collection of Court Gebeau,
Nashville, Tennessee

Flood, 2012
Acrylic, graphite on canvas
60 x 48 inches
Courtesy of the artist
and CANADA

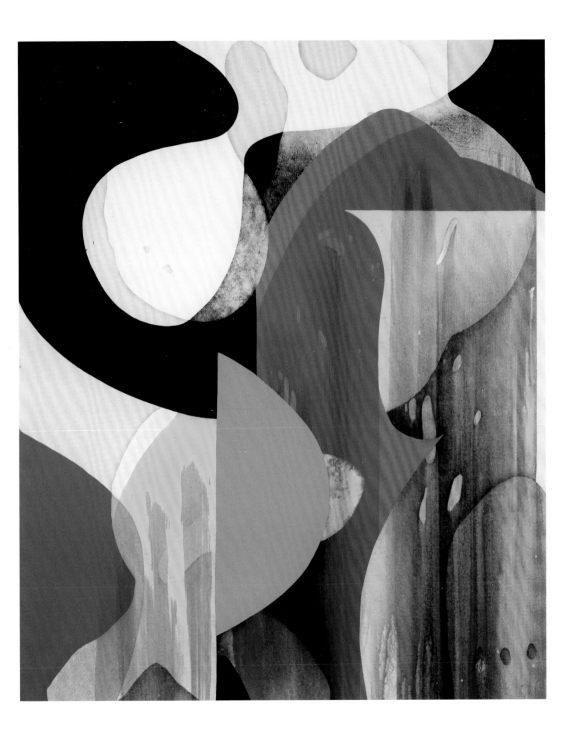

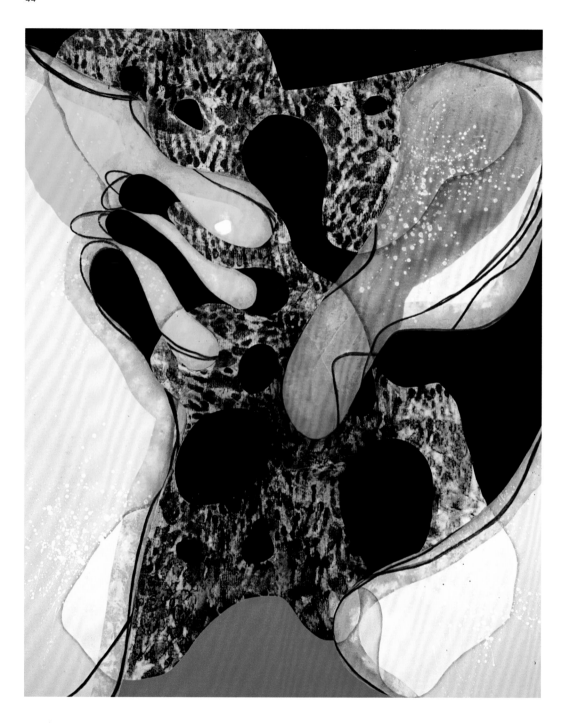

STRANGENESS

BY
BARRY
SCHWABSKY

IT MAY NOT BE IMMEDIATELY EVIDENT how much substance there is in Carrie Moyer's paintings, or what a long gestation they've had. And that's probably as it should be. After all, part of the pleasure the paintings give has to do with the artist's light touch in handling materials, images, and ideas. Unlike a lot of others who tend either to browbeat the viewer with signifiers of gravitas and depth or on the contrary to broadcast their cool nonchalance or apologetic diffidence about painting, Moyer takes her art with undoubted seriousness but would rather let the significance of her work sneak up on you only after you've been charmed by its verve and knockabout energy. For her, painting is neither a revival tent where she needs to get down on her knees to proclaim belief nor a therapist's office in which to belabor her doubt.

Because most of Moyer's admirers have come to know her work over the past decade or so—her first one-person show took place in 2000, the year before she earned her MFA in painting—they probably put in their mental pigeonhole for "young artists," forgetting that the roots of her work go much further back. The fact that she got her BFA in 1985 should serve as a reminder that her ideas about painting have been brewing for a long time; and that she also earned an MA in computer graphic design in 1990 suggests that her visual imagination has been stirred by far more than has entered into the purview of many other painters. Through the 1990s and on into the 2000s, Moyer was busy putting her graphic design skills to work as one-half of the agitprop duo Dyke Action Machine!, whose mission (as the DAM! website proclaims) was to foment "a hybrid form of public address where civic issues such were packaged to fit seamlessly into the commercialized streetscape." The DAM! approach was always attuned to the realization that while it is true that, as a poster

The Tiger's Wife, 2011
Acrylic, graphite on canvas
60 x 48 inches
Hall Collection

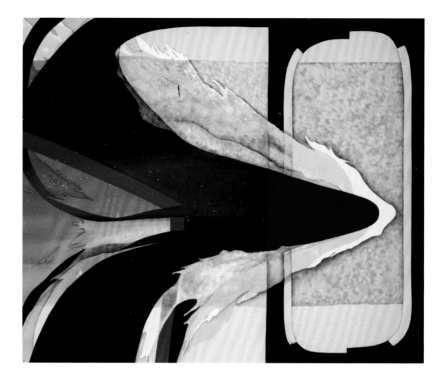

*Stroboscopic Painting
#1*, 2011
Acrylic, glitter on
canvas
60 x 72 inches
Pizzuti Collection,
Columbus, Ohio

of theirs once had it, "Clever slogans don't make a revolution," this did
not absolve them from having to at least have clever slogans and, for that
matter, an arresting graphic style.

While Moyer's paintings are devoid of slogans—clever or otherwise—
and mostly (though not entirely) without overt imagistic content, her
decades-long hopscotch from painting to design and back again to
painting probably has a lot to say about why her paintings look as they do
and why they feel so different from those of most other painters on the
scene. They present a curious dichotomy: Full as they are of painterly
nuance and spatial complexity, they nonetheless strike the viewer with a
direct and incisive graphic punch. So the works immediately claim your
attention but they don't stop there; their visual richness keeps you
involved. They typically work with a kind of space that is neither deep nor
flat; although the paintings are full of opaque forms they also encompass
translucent surfaces whose layers seem innumerable—as if there
might always be yet another sheer, wafting curtain of color to pass
through; you want to keep going further than you can actually see. But it's
the paintings' sense of immediacy is what allows Moyer to be so wide-
ranging in her stylistic choices without making the viewer feel that she is
merely concocting an eclectic pastiche in which the various parts fail to
relate to each other—a common failing of postmodern abstraction, which
is always implicitly defended with the excuse that failure to relate is

precisely the point of the exercise, since it reflects our atomized condition in contemporary society. Don't fall for that one, please! Moyer is here to remind us, on the contrary, that a strong and passionate statement—including the kind of statement that ultimately refuses to be encapsulated in words, as in the best abstract painting, though she equally relates her impulse toward clarity about the essentially mysterious experience of art to her work as a writer—can bring the most unlikely elements into relation.

I haven't seen the paintings that Moyer made as a student in the 1980s but in an interview with Phong Bui of *The Brooklyn Rail* she's described that as "bright, energetic biomorphic abstractions" with "a strong affinity with painters like Elizabeth Murray, Gary Stephan, Katherine Porter, Bill Jensen"—a description that still seems very relevant to one part of the mix that goes into her current work. Murray in particular seems germane, thanks to a playful pop sensibility toward abstract space that is closer to Moyer's own stance than either the earnest soulfulness of a Porter or Jensen or to the drier perceptual gamesmanship of Stephan's work of that era, but also because of Murray's deft way of warping space to keep the figurative associations of her forms in play without ever quite determining a necessarily figurative reading of the overall image.

Moyer told Bui that her 2003 exhibition "Chromafesto" (which I missed, since I was living abroad at the time) "was about seeing if the audience could 'read' political content in abstraction." (Of course, the title should have been a giveaway.) Am I failing the test if I confess that Moyer's more recent paintings don't seem terribly political to me—that I'd call them the unpolitical paintings of a political person? And yet I can't help remember that Fairfield Porter once pointed out the paradox that while the best way to write about representational art is by way of its formal qualities, the best way to write about abstract art is by way of its subject matter. To which he added the proviso—remember that he was a contemporary of the Abstract Expressionists and a particular admirer of de Kooning—that in abstraction the subject matter would most likely

Shebang, 2006
Acrylic, glitter on canvas
84 x 60 inches
Collection of Thomas Huerter,
Omaha, Nebraska

be the feelings of the artist. Today that's less likely to be the case, except where the artist has bought into identity politics. We may have to cast our hermeneutical nets more widely to catch an abstract painter's subject matter than viewers did in the 1950s. But still, Porter's dictum remains useful to the extent that it reminds that the art content of any work is likely to be a kind of something extra, something added to what is given by convention; and since in most representational art the subjects, already in themselves meaningful, have indeed been given by conventions—faces, battles, miracles, landscapes—the artist's individual contribution will most likely enter the painting through the form the artist brings to these subjects. In abstract art, by contrast, the artist's effort must be to imbue given forms with meaning. If a stripe, a square, a drip, or a brushstroke is to have any special significance, it will be through the painter's specific way of "performing" them or else through the "syntax" through which she inflects them from work to work. In Moyer's paintings, however—and this is something that she shares with other painters of her time—the things she paints are neither quite representational nor quite abstract, as Porter would have understood the terms. The shapes I see in her paintings often feel to me as if they have come from somewhere else, even if I can't put my finger on just where that is. They are not simply basic formal elements of painting—they remind me of other things. She is, as she once explained to fellow artist Steel Stillman, "cutting and pasting between styles," but in the process she is cutting and pasting pieces of imagery that bring with them homeopathic doses of their former referents. And so when I look at Moyer's painting, their forms come to me, not exactly with predetermined meanings, but with something like a tinge of meaning, a penumbra of meaning, even before I begin to explore the intricacies of how the artist has materialized them or brought them into implicit dialogue with what might be their other metamorphoses in other works of hers. They are, as she put it to Stillman, "vaguely familiar, but strange." This strangeness is the subject of the paintings.

Of course, making things strange (*ostranenie* in Russian) has been

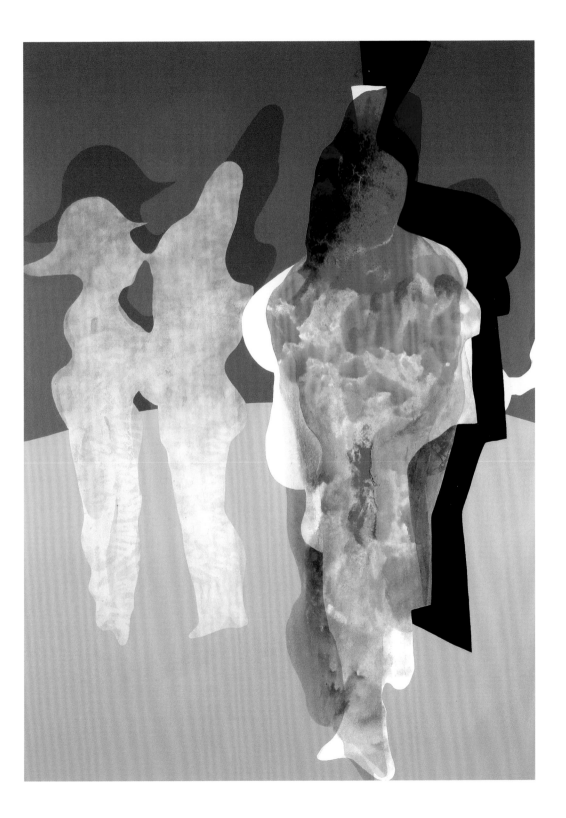

one of the great tasks of modernism (and, before it, of Romanticism). "The technique of art is to make objects 'unfamiliar,'" as Viktor Shklovskij proclaimed, "because the process of perception is an aesthetic end in itself and must be prolonged." Part of what drives the history of art is the fact that techniques for producing unfamiliarity in turn become familiar and need to be revised and challenged. Much modernist art was based on the strategy Shklovskij dubbed "baring the device"—the artwork displaying its own means. With much modernist painting, therefore, and in opposition to the classical "art that conceals art," one should be able to imaginatively reconstruct just how the painting was made. Not so with Moyer, who not only means to estrange images but also techniques. A visual trickster, she enjoys "subverting visual expectations and obfuscating the narrative of *how* the image got made," as she told Stillman. The painting unfolds in your perception of it but what that unfolding has to do with the previous process of its making may be moot. It's not that the painting is its own subject matter any more than its subject is the self of the painter; yet neither is the subject some namable topical theme either. Maybe what the subject is depends on how you look at it; but the how of looking is strange, and Moyer shows us that looking and seeing are all the more compelling for that.

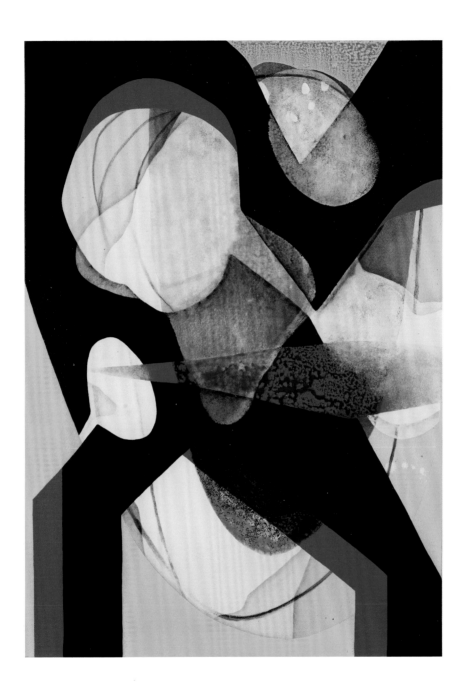

Mlle. X, 2012
Acrylic, glitter, graphite on canvas
40 x 28 inches
Courtesy of the artist and
CANADA

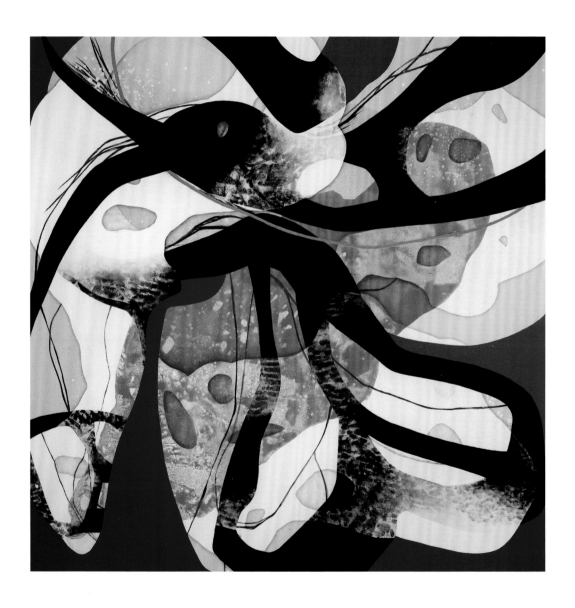

Into the Woods, 2011
Acrylic, glitter, graphite on canvas
72 x 72 inches
Pizzuti Collection,
Columbus, Ohio

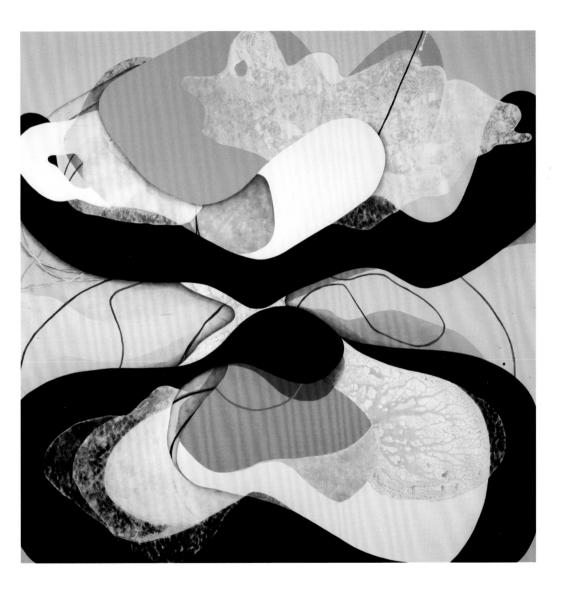

Frilly Dollop, 2011
Acrylic, graphite on canvas
72 x 72 inches
Collection of Merrill Mahan,
New York

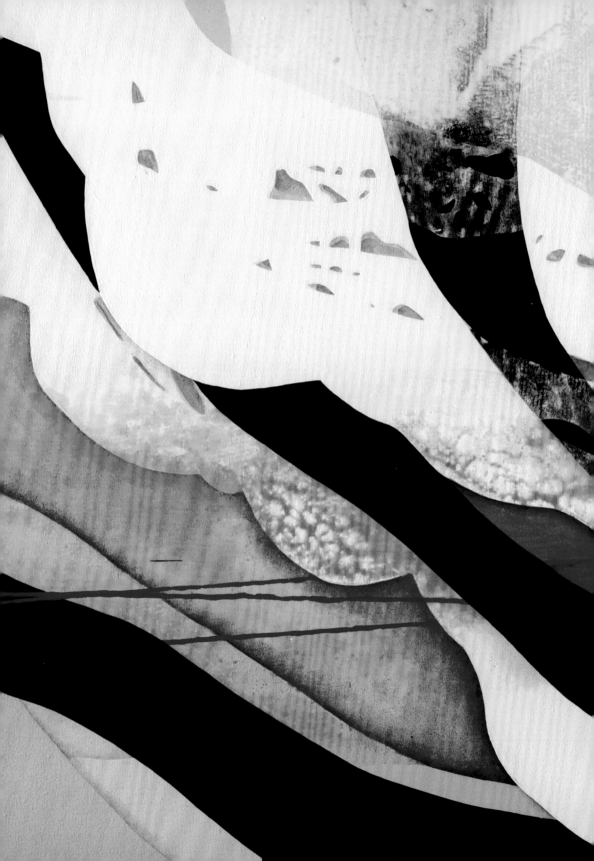

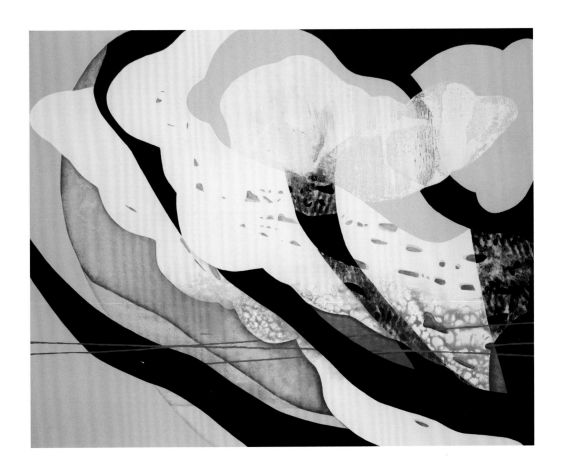

(above and detail facing)

Cherry Blossom Hour, 2011
Acrylic, graphite on canvas
48 x 60 inches
Collection of Bryan and Tara
Meehan, San Francisco

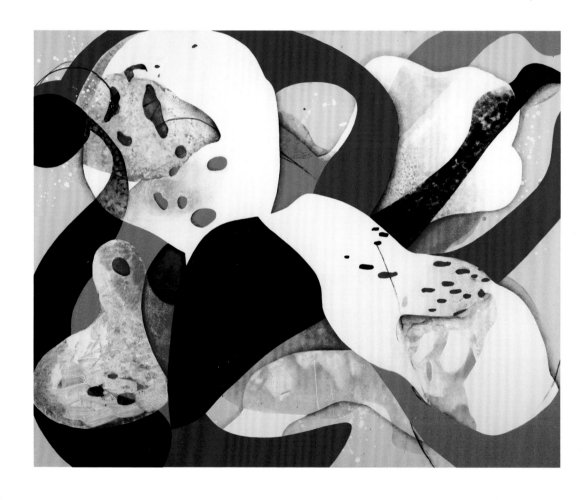

Diver, 2011
Acrylic, graphite on canvas
40 x 60 inches
Collection of the artist and
the Artist Pension Trust

(facing)

Hong Kong Garden, 2012
Acrylic, glitter, graphite
on canvas
40 x 28 inches
Private Collection

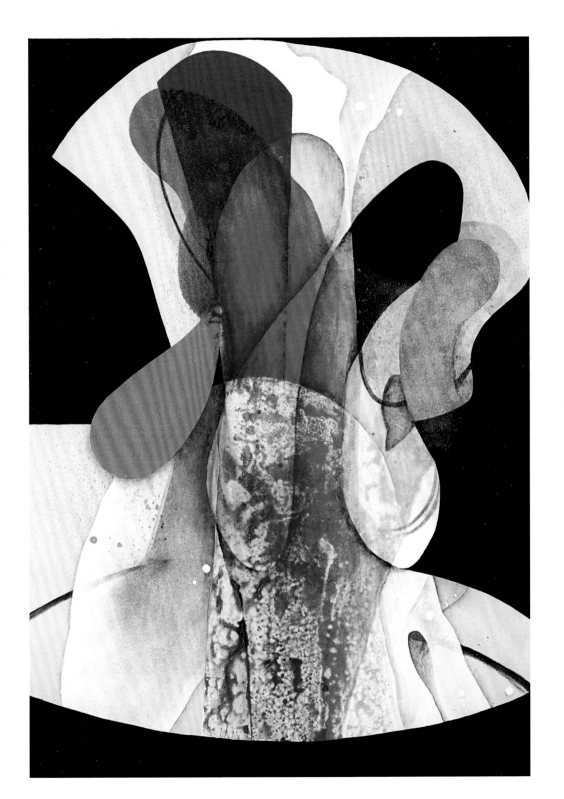

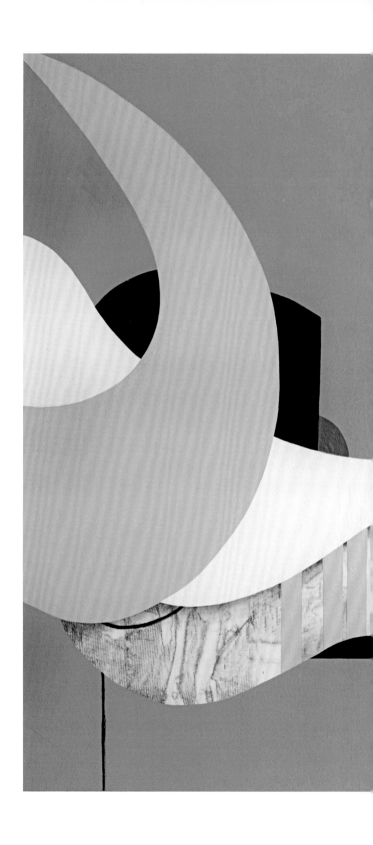

Herr Doktor, 2012
Acrylic, glitter, graphite
on canvas
56 x 72 inches
Collection of Mark and
Leigh Teixeira,
Marriottsville, Maryland

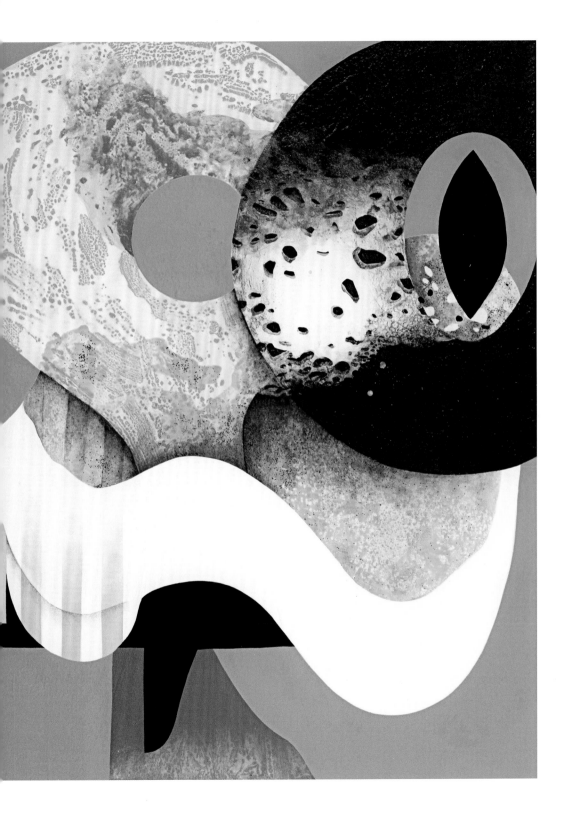

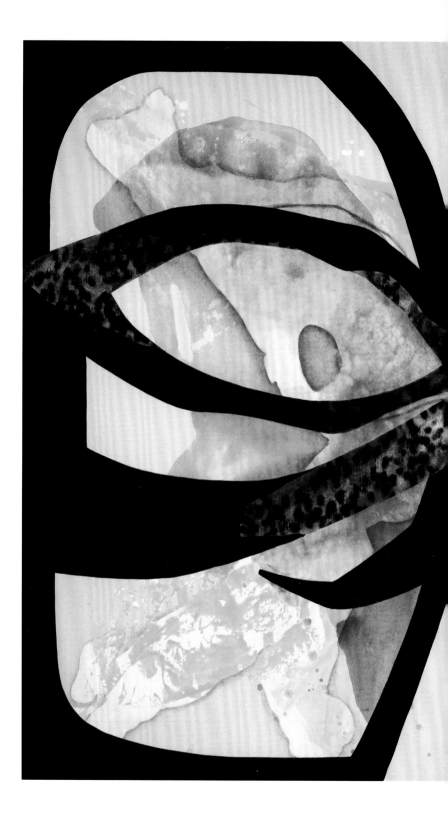

Rock Candy Chrysalis,
2011
Acrylic, graphite
on canvas
48 x 60 inches
Collection of Mike
Carpenter

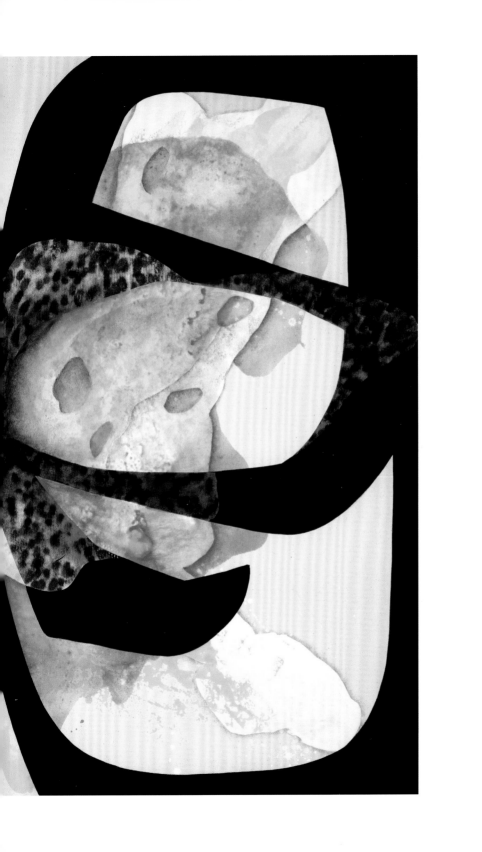

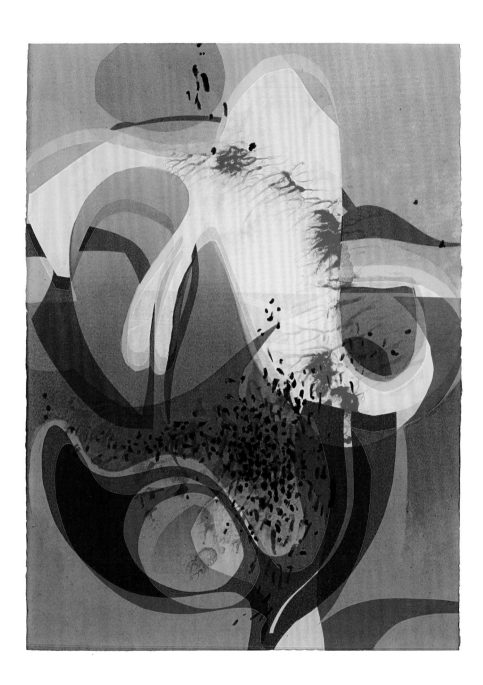

Untitled, 2012
Monotype
30 x 22 inches
Courtesy of the artist and
10 Grand Press

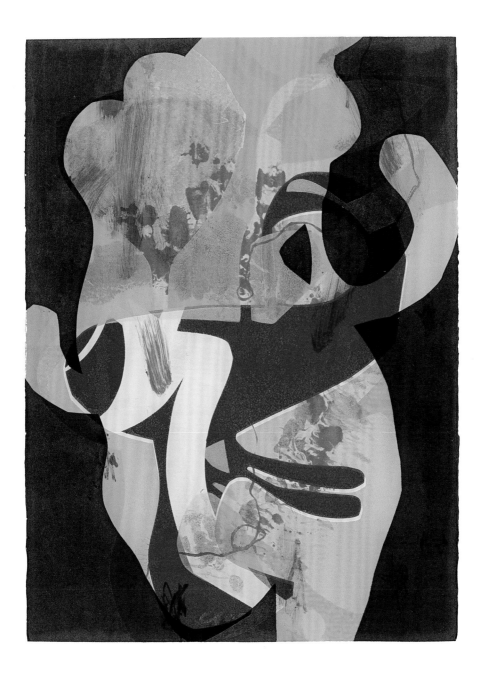

Untitled, 2012
Monotype
30 x 22 inches
Courtesy of the artist and
10 Grand Press

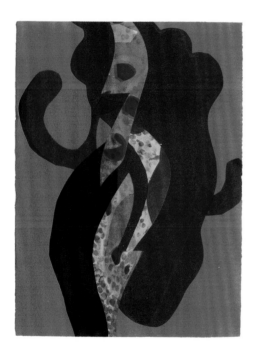

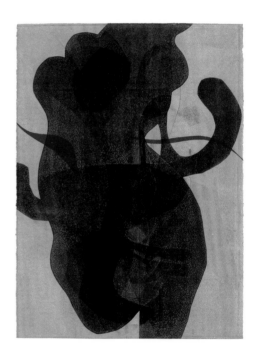

(left, right, and facing)

Untitled, 2012
Monotype
30 x 22 inches
Left: Private Collection
Right and facing page:
Courtesy of the artist and
10 Grand Press

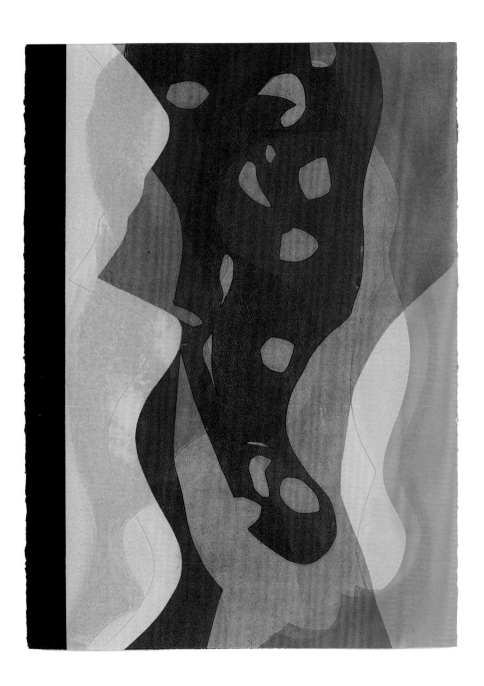

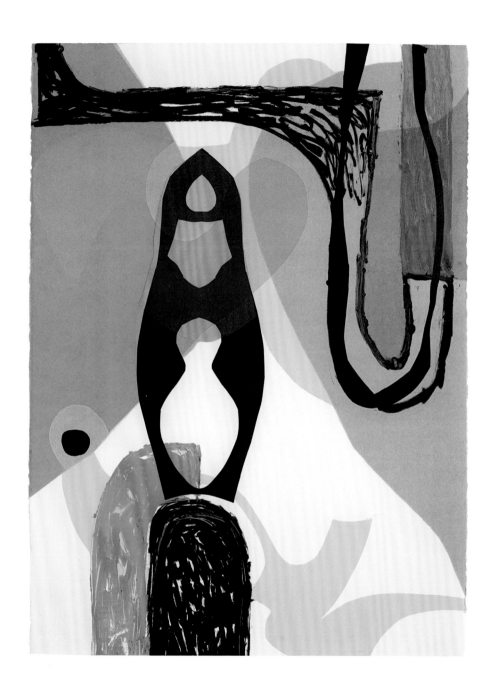

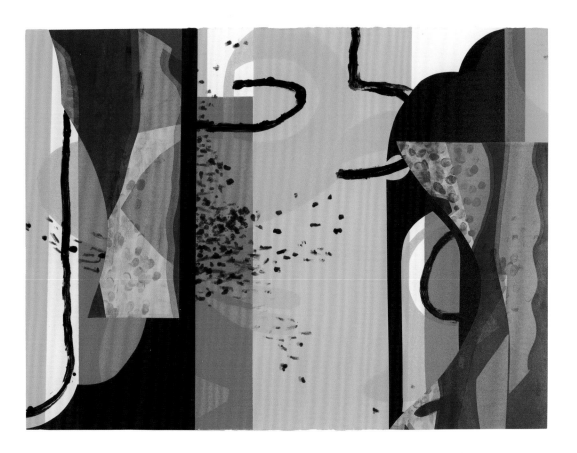

(facing)

Untitled, 2012
Monotype
30 x 22 inches
Courtesy of the artist and
10 Grand Press

Untitled, 2012
Monotype
30 x 22 inches
Courtesy of the artist and
10 Grand Press

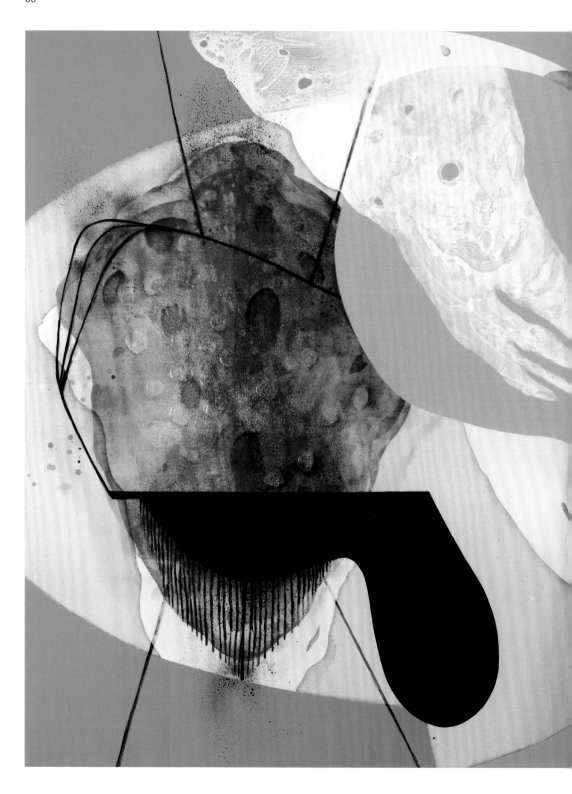

Rock Paper Scissors, 2012
Acrylic, glitter, graphite
on canvas
60 x 72 inches
Courtesy of the artist and
CANADA

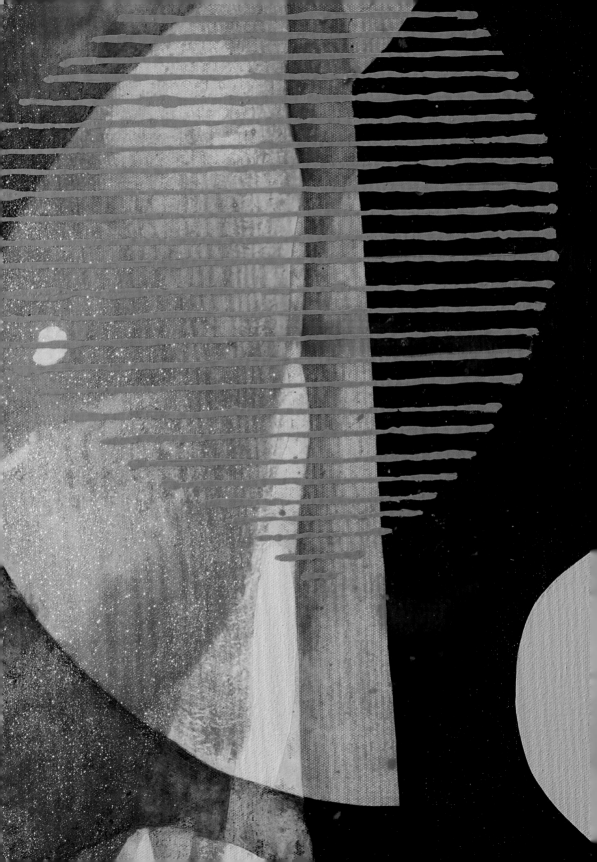

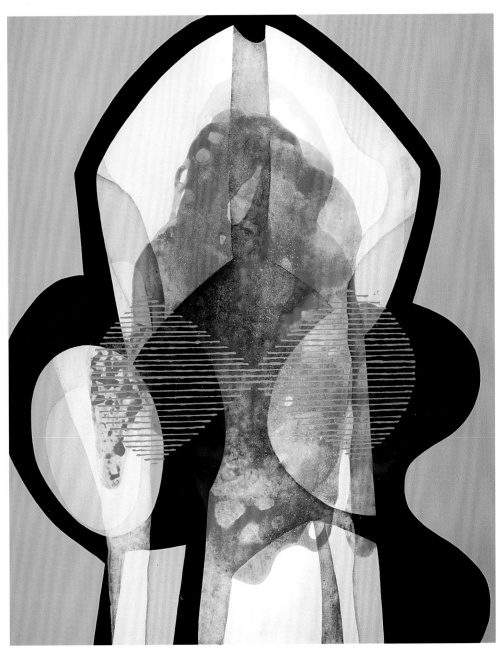

(above and detail facing)

Shady Construct, 2009
Acrylic, glitter on canvas
50 x 40 inches
Collection of The Tang
Teaching Museum, Skidmore
College, gift of the artist,
2013.10

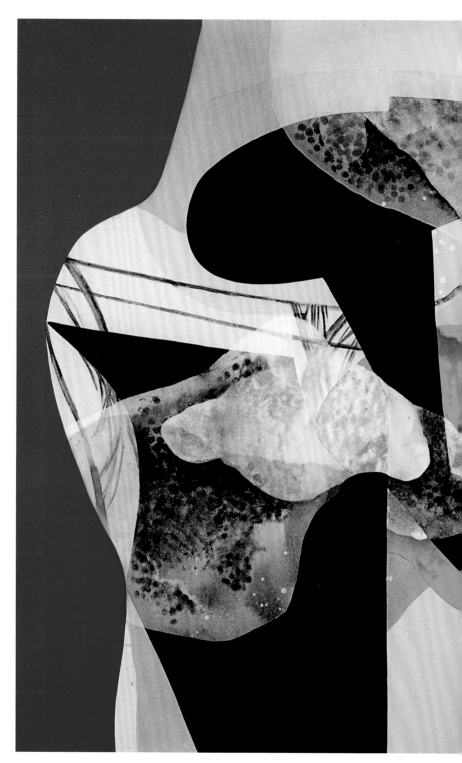

Motor Belly, 2012
Acrylic, graphite on
canvas
60 x 72 inches
Courtesy of the artist
and CANADA

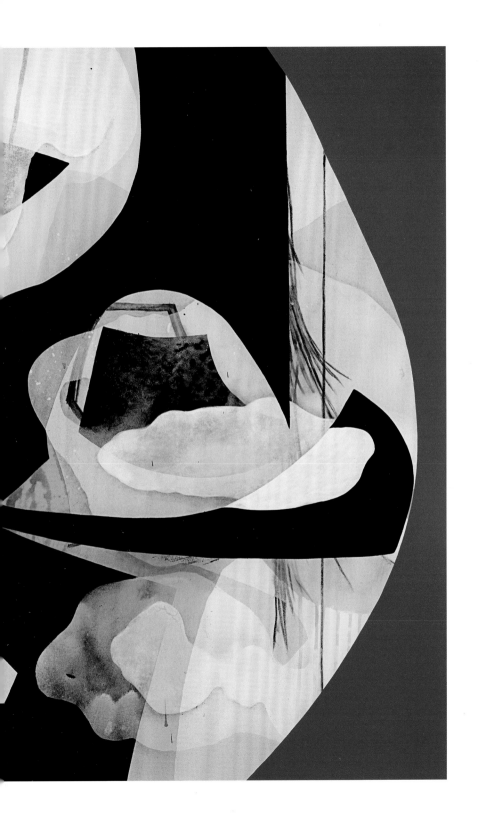

Pirate Jenny, 2012
Acrylic, graphite on canvas
72 x 72 inches
Courtesy of the artist and
CANADA

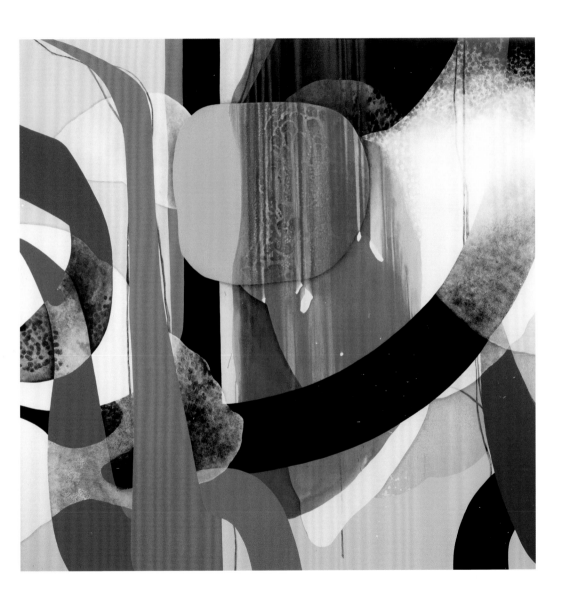

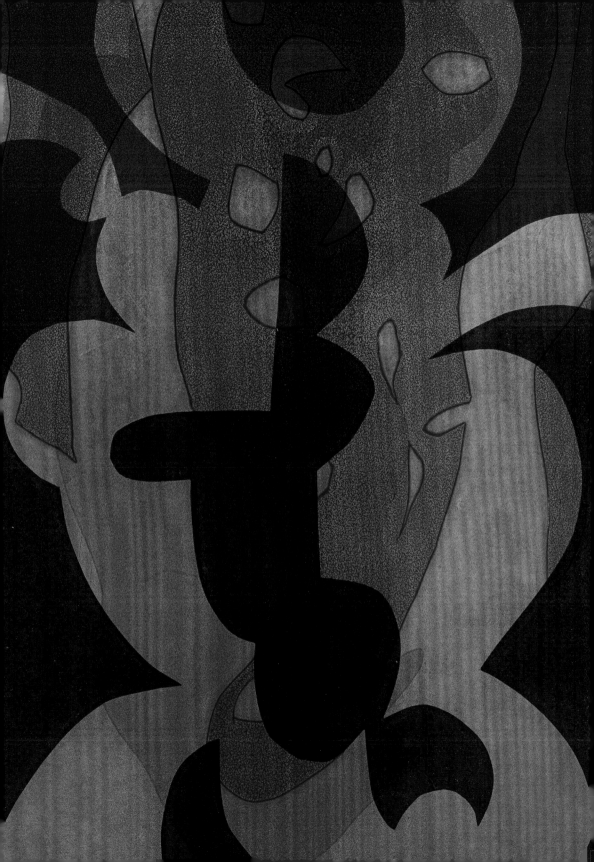

CHECKLIST

All works by
Carrie Moyer

Dimensions listed in inches
height x width

Works listed for Tang
venue only

1
Queen Bee I, 2006
Acrylic, glitter on canvas
40 x 28
Collection of Mary Sanger
and Kay Turner

2
Skullspout, 2007
Acrylic, glitter on canvas
24 x 18
Collection of the artist

3
Ballet Mécanique, 2008
Acrylic, glitter on canvas
80 x 60
Collection of the artist

4
Tableau, 2008
Acrylic, glitter on canvas
90 x 66
Collection of the artist

5
Rapa Nui Smashup, 2009
Acrylic, glitter on canvas
60 x 40
Worcester Art Museum,
Worcester, Massachusetts,
promised gift

6
Shady Construct, 2009
Acrylic, glitter on canvas
50 x 40
Collection of The Tang
Teaching Museum, Skidmore
College, gift of the artist,
2013.10

Untitled, 2012
Monotype
30 x 22 inches
Collection of Patricia
and David Moyer

7
Cherry Blossom Hour, 2011
Acrylic, graphite on canvas
48 x 60
Collection of Bryan and Tara
Meehan, San Francisco

8
Carnivalesque, 2012
Acrylic, glitter, graphite
on canvas
60 x 48
Courtesy of the artist
and CANADA

9
Herr Doktor, 2012
Acrylic, glitter, graphite
on canvas
56 x 72
Collection of Mark and
Leigh Teixeira, Marriottsville,
Maryland

10
Hook, Line & Sinker, 2012
Acrylic, graphite on canvas
72 x 60
Private Collection

11
Mlle. X, 2012
Acrylic, glitter, graphite
on canvas
40 x 28
Courtesy of the artist
and CANADA

12
Motor Belly, 2012
Acrylic, graphite on canvas
60 x 72
Courtesy of the artist
and CANADA

13
Pirate Jenny, 2012
Acrylic, graphite on canvas
72 x 72
Courtesy of the artist
and CANADA

14
Rock Paper Scissors, 2012
Acrylic, glitter, graphite
on canvas
60 x 72
Courtesy of the artist
and CANADA

15
Untitled, 2012
Monotype
30 x 22
Courtesy of the artist and
10 Grand Press

16
Untitled, 2012
Monotype
30 x 22
Courtesy of the artist and
10 Grand Press

17
Untitled, 2012
Monotype
30 x 22
Courtesy of the artist and
10 Grand Press

18
Untitled, 2012
Monotype
30 x 22
Collection of Patricia and
David Moyer

19
Untitled, 2012
Monotype
30 x 22
Courtesy of the artist and
10 Grand Press

20
Untitled, 2012
Monotype
30 x 22
Courtesy of the artist and
10 Grand Press

21
Untitled, 2012
Monotype
30 x 22
Courtesy of the artist and
10 Grand Press

22
Untitled, 2012
Monotype
30 x 22
Courtesy of the artist and
10 Grand Press

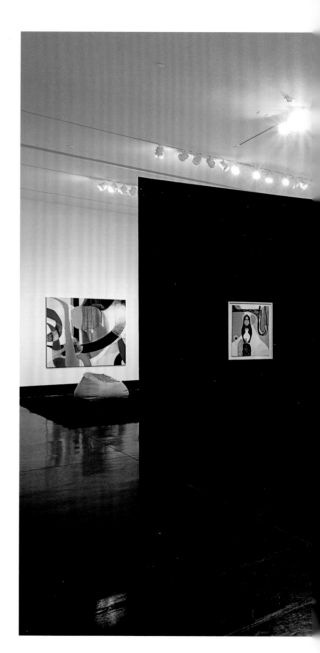

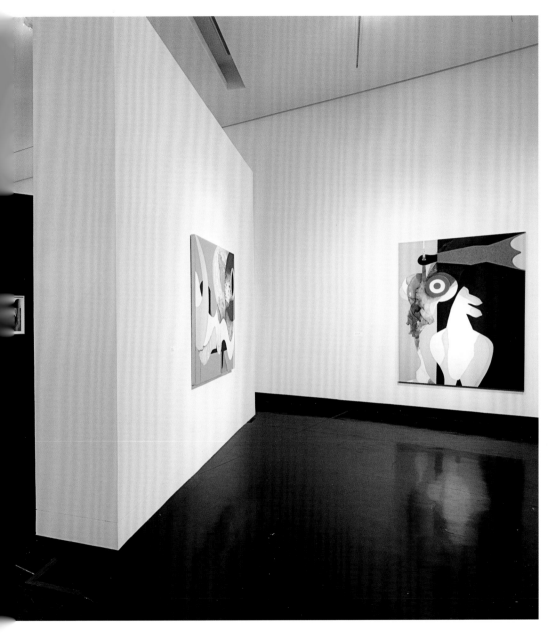

Installation view,
Tang Museum, Saratoga
Springs, New York, 2013

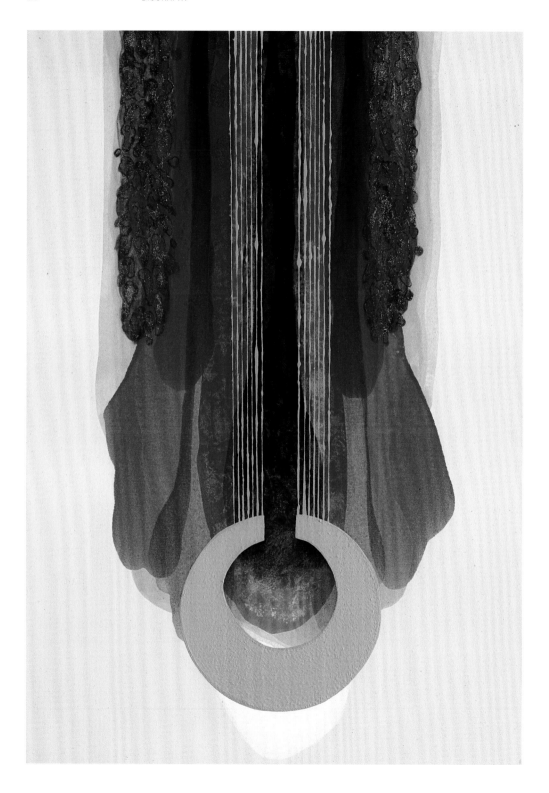

CARRIE MOYER

BORN IN DETROIT,
MICHIGAN, IN 1960

LIVES AND WORKS IN
BROOKLYN, NEW YORK

Queen Bee I, 2006
Acrylic, glitter on canvas
40 x 28 inches
Collection of Mary
Sanger and Kay Turner

EDUCATION

2001
M.F.A., Milton Avery Graduate
School of the Arts, Bard
College, Annandale-on-
Hudson, New York

1995
Skowhegan School of Painting
and Sculpture, Skowhegan,
Maine

1990
M.A., New York Institute of
Technology, New York

1985
B.F.A., Pratt Institute,
New York

From 1991 to 2004 Carrie
Moyer collaborated with
Sue Schaffner as Dyke
Action Machine! (DAM!).
The exhibitions listed below
included works Moyer
made on her own as well as
collaboratively as DAM!

SOLO EXHIBITIONS

2013
*Opener 24 Carrie Moyer: Pirate
Jenny*, The Frances Young
Tang Teaching Museum and
Art Gallery at Skidmore
College, Saratoga Springs,
New York, January 26–May 19;
traveled to Columbus College
of Art and Design, Columbus,
Ohio, February 6 – May 1,
2014; Savannah College of Art
and Design, Savannah,
Georgia, 2014.

2012
*Straight to Hell: Twenty Years
of Dyke Action Machine!*,
Lesbian Herstory Archives,
Brooklyn, New York, October
7–January 31, 2013

Interstellar, Worcester Art
Museum, Worcester,
Massachusetts, February 11–
August 19

2011
Canonical, CANADA, New
York, September 14–October
16

2009
Arcana, CANADA, New York,
May 7–June 7

*Carrie Moyer: Painting
Propaganda*, American
University Museum, Katzen
Arts Center, American
University, Washington, D.C.,
January 24–March 15

2007
Black Sun: New Paintings,
Hunt Gallery, Mary Baldwin
College, Staunton, Virginia,
March 19–April 6

The Stone Age, CANADA, New
York, January 7–February 11

Black Gold, Rowland
Contemporary, Chicago,
Illinois

2004
Façade Project, Triple Candie,
New York, February 1–May 2

2002
Hail Comrade!, Debs & Co.,
New York, December 5–
January 11, 2003

Meat Cloud, Debs & Co.,
New York, May 9–June 15

*Straight to Hell: 10 Years of
Dyke Action Machine!*, Yerba
Buena Center for the Arts,
San Francisco, California,
May 4–July 14; traveled to:
DiverseWorks Art Space,
Houston, Texas

The Bard Paintings, Gallery @
Green Street, Boston,
Massachusetts, January 11–
February 9

2000
God's Army, Debs & Co., New
York, October–November 22

SELECTED GROUP EXHBITIONS

2013
Pour, Schmidt Center Gallery,
Florida Atlantic University,
Boca Raton, Florida, February
5–March 23

The White Album, Louis B.
James, New York, January
11–February 22

2012

Simpatico, Boston University Art Gallery, Boston, Massachusetts, September 7–October 21

B-Out, Andrew Edlin Gallery, New York, July 5–August 18

Beasts of Revelation, DC Moore Gallery, New York, June 21–August 3

Carrie Moyer & Les Rogers, Galerie Suzanne Tarasieve, Paris, France, May 12–June 23

Five by Five, DC Moore Gallery, New York, May 3–June 15

Risk + Reward, Foster Gallery, University of Wisconsin-Eau Claire, Eau Claire, Wisconsin, January 26–February 16

2011

A Painting Show, Harris Lieberman, New York, May 6–June 4

2010

Vivid: Female Currents in Painting, Schroeder Romero & Shredder, New York, November 18–January 22, 2011

Pictures Hold Us Captive: Carrie Moyer & Jered Sprecher, Downtown Gallery, University of Tennessee, Knoxville, Tennessee, November 5–November 24

Raw State, 222 Shelby Street Gallery, Santa Fe, New Mexico, October 5–December 7

The Jewel Thief, The Frances Young Tang Teaching Museum and Art Gallery at Skidmore College, Saratoga Springs, New York, September 18–February 27, 2011

Ultrasonic IV: It's Only Natural, Mark Moore Gallery, Culver City, California, September 11–October 16

Daniel Hesidence Curates, Tracy Williams Ltd., New York, July 9–August 6

Love Never Dies, Form+Content Gallery, Minneapolis, Minnesota, May 20–June 27

2009

Don't Perish, Leo Koenig Inc., New York, September 18–October 17

Artists Run Chicago, Hyde Park Art Center, Chicago, Illinois, May 10–July 5

Yo Mama: Sheila Pepe and Friends, Naomi Arin Contemporary Art, Las Vegas, Nevada, February 20–March 29

One Loses One's Classics, White Flag Projects, St. Louis, Missouri, January 17–February 15

Infinite Possibilities, Momenta Art, Brooklyn, New York, January 9–February 9

2008

Duck Soup, La Mama La Galleria, New York, November 21–December 21

Convergences/Center Street Studio, Galerie Mourlot, New York, November 20–January 3, 2009

Artcrush, Jenny Jaskey Gallery, Philadelphia, Pennsylvania, October 4–October 13

That Was Then...This Is Now, MoMA PS1, Long Island City, New York, June 22–October 5

Reclaiming the "F" Word: Posters on International FeminismS, Art Gallery, Mike Curb College of Arts, Media, and Communication, California State University, Northridge, California, June 3–July 4

Publishing Prints: Selections from the Center Street Studio Archives, Joel and Lila Harnett Museum of Art, University of Richmond, Richmond, Virginia, February 6–April 9

Unnameable Things, Artspace, New Haven, Connecticut, February 2–March 29
Freeze Frame, Thrust Projects, New York, January 11–February 17

Break the Rules! Sammlung Hieber/Theising, Mannheimer Kunstverein, Mannheim, Germany, January 6–February 3

2007

boundLES: Celebrating Contemporary Art on the Lower East Side, Abrons Art Center at Henry Street Settlement, New York, November 27–January 13, 2008

Don't Let the Boys Win, Mills College Art Museum, Oakland, California, September 19–December 9

Late Liberties, John Connelly Presents, New York, July 12–August 24

Project: Rendition, Momenta Art, Brooklyn, New York, May 25–June 25

Absolute Abstraction, Judy Ann Goldman Fine Art, Boston, Massachusetts, March 15–April 14

Hot and Cold: Abstract Prints from the Center Street Studio, Trustman Art Gallery, Simmons College, Boston, Massachusetts, March 15–April 20

Beauty is in the Street: The Iconography of Idealism, Mason Gross Galleries, Rutgers University, New Brunswick, New Jersey, May 9–June 8; traveled to: Bronx River Art Center, Bronx, New York, January 11–December 16, 2008

Affinities: Painting in Abstraction, Hessel Museum of Art, Bard College, Annandale-on-Hudson, New York, March 11–March 25; traveled to: Kresge Gallery, Berrie Center for Performing and Visual Arts, Ramapo College of New Jersey, Mahwah, New Jersey, November 5–December 12, 2008; Memorial Hall Painting Department Gallery, Rhode Island School of Design, Providence, Rhode Island, September 16–October 21, 2009; D'Ameilo Terras, New York, June 30–August 19, 2011

Shared Women, LACE (Los Angeles Contemporary Exhibitions), Los Angeles, California, February 28–April 8

Mother, May I?, Campbell-Soady Gallery, The Lesbian, Gay, Bisexual & Transgender Community Center, New York, February 1–April 26

Fragments of Change, Ernst Rubenstein Gallery, Educational Alliance, New York, January 25–March 1

2006

Papering, Deutsche Bank, New York, April 18–August 5

Ridykeulous, Participant, Inc., New York, March 10–April 2

When Artists Say We, Artists Space, New York, March 8–April 29

Carrie Moyer and Diana Puntar, Samsøn Projects, Boston, Massachusetts, February 3–March 11

Do You Think I'm Disco?, Longwood Art Gallery, Hostos Community College, Bronx, New York, January 7–March 18

2005

Twofold: Collaborations on Campus, Richard L. Nelson Gallery & Fine Arts Collection, University of California, Davis, California, September 29–December 11

Around About Abstraction, Weatherspoon Art Museum, University of North Carolina, Greensboro, North Carolina, June 12–October 2

Dissent: Political Voices, SPACES, Cleveland, Ohio, April 15–June 10

eva International Biennial of Visual Art, Limerick, Ireland, March 11–May 22

New York's Finest, CANADA, New York, January 29–March 5

Group Exhibition, Marlborough Gallery Chelsea, New York

BAM Next Wave Visual Art, Brooklyn Academy of Music, Brooklyn, New York

2004

Sister Resister, DiverseWorks Art Space, Houston, Texas, September 16–November 6

Watch What We Say, Schroeder Romero & Shredder, Brooklyn, New York, August 26–September 2

Republican Like Me, Parlour Projects, Brooklyn, New York, August 17–September 20

Explosion LTTR: Practice More Failure, Art in General, New York, July 17–August 21

Two Women: Carrie Moyer and Sheila Pepe, Palm Beach Institute of Contemporary Art, Lake Worth, Florida, June 26–August 29

About Painting, The Frances Young Tang Teaching Museum and Art Gallery at Skidmore College, Saratoga Springs, New York, June 26–September 26

Cakewalk, Ambrosino Gallery, Miami, Florida, May 28–July 3

2003

Chromafesto, CANADA, New York, December 6–January 8, 2004

Ameri©an Dre@m: A Survey, Ronald Feldman Fine Arts, New York, February 22–April 5

Adventures in Abstraction, Judy Ann Goldman Fine Art, Boston, Massachusetts

2002

Illegal Art: Freedom of Expression in the Corporate Age, CBGB's 313 Gallery, New York, November 13–December 6; traveled to: In These Times, Chicago, Illinois, January 25–February 21, 2003; SFMOMA Artists Gallery, San Francisco, California, July 2–July 29, 2003

Raw Womyn, ATHICA (Athens Institute of Contemporary Art), Athens, Georgia, March 9–April 6

Queer Commodity, Mount Saint Vincent University Art Gallery, Halifax, Nova Scotia, Canada, March 7–April 28

Unjustified, Apexart, New York, January 30–March 2

2001

OutArt: Stand Fast Dick & Jane, Project Arts Centre, Dublin, Ireland, June 29–July 28

Beyond the Center, Bard College Exhibition Space, Red Hook, New York, February 18–March 2

2000

The Color of Friendship, Shedhalle, Zürich, Switzerland, May 5–June 12

The Hissing of Summer Lawns, Debs & Co., New York

The Biggest Games in Town, Künstlerwerkstatt Lothringer Straße, Munich, Germany

1999

Size Matters, Gale Gates Gallery, Brooklyn, New York, December

Close to You, Gallery @ Green Street, Boston, Massachusetts, September 17–October 16

Unbehagen der Geschlechter/ Gender Trouble, NAK (Neuer Aachener Kunstverein), Aachen, Germany, May 30–July 11

Zone of Risibility, Rotunda Gallery, Brooklyn, New York, February 4–March 27

Free Coke, Greene Naftali Gallery, New York, January 30–March 13

1998

Message To Pretty, Thread Waxing Space, New York, November 21–December 19

Freedom, Liberation and Change: Revisiting 1968, Longwood Arts Gallery, Hostos Community College, Bronx, New York, February 14–April 11

1997

Vraiment: Féminisme et Art, Le Magasin, Centre National d'Art Contemporain de Grenoble, France, April 6–May 25

Installation view,
Tang Museum,
Saratoga Springs,
New York, 2013

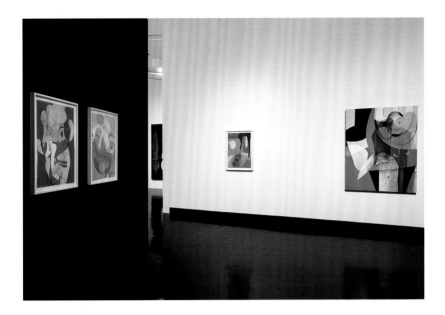

*National and International
Studio Program Exhibition*,
MoMA PS1, Long Island City,
New York

Patriotism, The Lab, San
Francisco, California

Revolution Girl-Style,
MuseumsQuartier, Vienna,
Austria

1996
*Portraiture: Contemporary
Photographs,* White Columns,
New York, December 6–
January 12, 1997

*Design on the Street: Mixing
Messages in Public Space*,
Cooper-Hewitt National
Design Museum, New York,
October 3–November 23

Gender, Fucked, Center on
Contemporary Art, Seattle,
Washington, June 28–August
23

*Counterculture: Alternative
Information from the
Underground Press to the
Internet*, Exit Art, New
York, February 24–June 1

1995
*You Are Missing Plenty If You
Don't Buy Here: Images of
Consumerism in American
Photography*, Frances Lehman
Loeb Art Center, Vassar
College, Poughkeepsie, New
York, January 27–March 26

In A Different Light, Berkeley
Art Museum & Pacific
Film Archive, University of
California, Berkeley,
California, January 11–April 9

Copy-Art, Carl von Ossietzky
Oldenburg University,
Oldenburg, Germany

Re-Configuring the Figure,
Creative Arts Workshop,
New Haven, Connecticut

1994
Ways in Being Gay, Hallwalls
Contemporary Arts Center,
Buffalo, New York, November
1–December 17

*Becoming Visible: The Legacy
of Stonewall,* New York Public
Library, New York, June 18–
September 24

No More Nice Girls, ABC
No Rio, New York, March 4–
April 1

*Paperworks: Prints From the
Lower East Side Printshop,*
SUNY Rockland Community
College, Suffern, New York

1993
SILENCE=DEATH, Münchner
Stadtmuseum, Munich,
and Hygiene-Museum,
Dresden, Germany, February
19–March 28

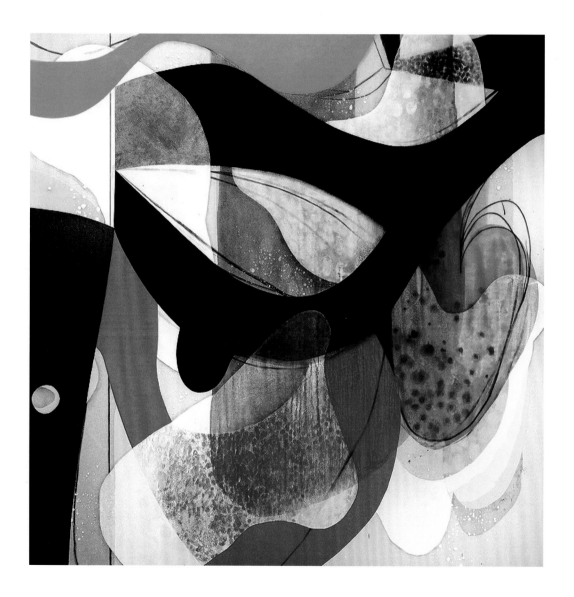

BIBLIOGRAPHY

SELECTED BOOKS, CATALOGUES, AND BROCHURES

Berry, Ian, ed. *Opener 24 Carrie Moyer: Pirate Jenny*. Exhibition catalogue. Saratoga Springs, New York: The Frances Young Tang Teaching Museum and Art Gallery at Skidmore College, 2013.

Blake, Nayland, Lawrence Rinder, and Amy Scholder, eds. *In A Different Light: Visual Culture, Sexual Identity, Queer Practice*. Exhibition catalogue. San Francisco: City Lights Books, 1995.

Bronfen, Elisabeth, and Misha Kavka, eds. *Feminist Consequences: Theory for the New Century*. New York: Columbia University Press, 2001.

Butler, Cornelia H., and Alexandra Schwartz, eds. *Modern Women: Women Artists at the Museum of Modern Art*. New York: Museum of Modern Art, 2010.

Cottingham, Laura, Françoise Collin, and Armelle Leturcq. *Vraiment: Féminisme et Art*. Exhibition catalogue. Grenoble, France: Magasin, 1997.

Deitcher, David, ed. *The Question Of Equality: Lesbian and Gay Politics in America Since Stonewall*. New York: Scribner, 1995.

Fort, Ilene Susan, Teresa Arcq, and Terri Geis, eds. *In Wonderland: The Surrealist Adventures of Women Artists in Mexico and the United States*. Exhibition catalogue. Los Angeles: Los Angeles County Museum of Art; New York: Prestel, 2012.

Hammond, Harmony. *Lesbian Art in America: A Contemporary History*. London: Rizzoli, 2000.

Lawton, Rebecca. *You Are Missing Plenty If You Don't Buy Here: Images of Consumerism in American Photography*. Exhibition catalogue. Poughkeepsie, New York: Frances Lehman Loeb Art Center, Vassar College, 1995.

Levin, Amy K. ed. *Gender, Sexuality, and Museums: A Routledge Reader*. New York: Routledge, 2010.

MacPhee, Josh, ed. *Celebrate People's History: The Poster Book of Resistance and Revolution*. New York: The Feminist Press at the City University of New York, 2010.

McQuiston, Liz. *Graphic Agitation 2: Social and Political Graphics in the Digital Age*. London: Phaidon Press, 2004.

——. *Suffragettes to She-Devils: Women's Liberation and Beyond*. London: Phaidon Press, 1997.

Nickas, Robert. *Painting Abstraction: New Elements in Abstract Painting*. London: Phaidon Press, 2009.

Saks, Jane M. *Unjustified*. Exhibition brochure. New York: Apexart Curatorial Program, 2012.

Stoops, Susan L. *Carrie Moyer: Interstellar*. Exhibition brochure. Worcester, Massachusetts: Worcester Art Museum, 2012.

Turner, Kay, ed. *Dear Sappho: A Legacy of Lesbian Love Letters*. London: Thames & Hudson, 1996.

(facing)

Kashmir, 2012
Acrylic on canvas
72 x 72 inches
Collection of the Birmingham Museum of Art, purchase with funds provided by the Collectors Circle for Contemporary Art, 2012.59

SELECTED ARTICLES AND REVIEWS

von Arbin Ahlander, Astri. "Carrie Moyer: Interview." *Daysofyore.com* (9 April 2012).

Atkins, Robert. "Scene & Heard." *Village Voice* 39, no. 28 (12 July 1994): 72.

Baker, Kenneth. "Women's Art at Mills Mixes Defiance, Humor." *San Francisco Chronicle* (20 October 2007): E10.

Barnett, Kari. "Summer Exhibition Opens at PBICA." *Lake Worth Forum* (29 June 2004).

Becker, Jochen. "Unbehagen der Geschlechter." *Kunstforum International* 147 (September–November 1999): 410–412.

Bryan-Wilson, Julia. "Carrie Moyer." *Artforum* 45, no. 8 (April 2007): 278–279.

Bui, Phong. "In Conversation: Carrie Moyer with Phong Bui." *Brooklyn Rail* (September 2011).

Carlin, T. J. "Carrie Moyer: Arcana." *Time Out New York* (21–27 May 2009).

Che, Cathay. "DAM! Sell in Distress." *Time Out New York* (July 1998).

Clark, Emilie, and Lytle Shaw, eds. *SHARK: A Journal of Poetics and Art Writing*, no. 3 (Winter 2001).

Coates, Jennifer. "Review: Carrie Moyer, 'Canonical.'" *Time Out New York* (27 September 2011).

Conner, Jill. "Freeze Frame." *artUS* (January/February 2008): 46.

Costello, Devon, and Esme Watanabe. "Ameri©an Dre@m." *NY Arts Magazine* 8, no. 4 (April 2003): 17.

Cotter, Holland. "Do You Think I'm Disco?" *New York Times* (3 February 2006): E37.

———. "Innovators Burst Onstage One (Ka-pow!) at a Time." *New York Times* (10 November 2000): E31.

———. "Unjustified." *New York Times* (1 March 2002): 44.

Daderko, Dean. "A Mirrorball to Liberation." *Gay City News* 5, no. 4 (26 January–1 February 2006).

Delaney, Anngel. "For Art's Sake: New Book on Lesbian Art Fills a Void." *New York Blade News* (29 September 2000): 18.

———. "Radical Re-visionary." *New York Blade News* (8 September 2000).

Feinstein, Roni. "Carrie Moyer and Sheila Pepe at the Palm Beach ICA." *Art in America* 92, no. 11 (December 2004): 144–145.

———. "Exhibit Highlights 'Two Women' on Different Paths." *South Florida Sun-Sentinel* (11 August 2004): 3E.

"Freeze Frame." *Time Out New York* (24–30 January 2008): 64.

Fry, Naomi. "Critics Picks: Carrie Moyer." *Artforum.com* (21 January 2007).

"Galleries—Downtown: Carrie Moyer." *New Yorker* (1 June 2009): 15.

"Galleries—Downtown: Carrie Moyer." *New Yorker* (12 February 2007).

"Galleries—Downtown: Carrie Moyer." *New Yorker* (17 October 2011.

"Galleries—Downtown: Tom Johnson/Carrie Moyer." *New Yorker* (12 January 2004): 16.

Genocchio, Benjamin. "Exploring the Effects of Disco's Beat." *New York Times* (19 February 2006): 8.

———. "Young and Provocative, Time Is on Their Side." *New York Times* (12 September 2004): NJ15.

Goodbody, Bridget L. "Late Liberties." *New York Times* (3 August 2007): 31.

Greenfield, Beth. "Designs on You." *Time Out New York* (23–30 September 2004).

Grubb, R. J. "Love, Peace & Work by Carrie Moyer." *Bay Windows* (5 February 2002).

Halden, Loann. "Art, Activism and Intimacy." *TWN: The Weekly News* (8 July 2004).

Hammes, Mary Jessica. "Exploring the Feminine: Inaugural Exhibit At ATHICA Opens the Door on Women's Issues." *Athens Banner-Herald* (7 March 2002).

Hannaham, James. "Best of the Net: Dyke TV." *Village Voice* 41, no. 22 (28 May 1996): 18.

Harris, Elise. "Agit Pop." *Out* (July 1996).

Hirsch, Faye. "Carrie Moyer at CANADA." *Art in America* 95, no. 6 (June/July 2007): 196.

Holliday, Frank. "Abstraction Reconsidered." *Gay City News* (26 July–1 August 2007).

———. "A Partnership of Ideals." *Gay City News* 3, no. 332 (5–11 August 2004).

———. "Queering the Modern." *Gay City News* 3, no. 353 (30 December 2004–5 January 2005).

Hopkins, Randi. "Stealing Beauty: Fashion, Photography, Video, and Painting." *Boston Phoenix* (5 January 2002).

Ingram, Gordon Brent. "In Search of Queer Space on the Internet." *Border/Lines* (Fall 1996).

Jaskey, Jenny. "Vivid: Female Currents in Painting." *Art Lies* 67 (Fall/Winter 2010).

Johnson, Ken. "American Dream." *New York Times* (14 March 2003): E41.

Joselit, David. "Exhibiting Gender." *Art in America* 85, no. 1 (January 1997): 36.

Joy, Jenn. "Two Women: Carrie Moyer and Sheila Pepe." *Contemporary*, no. 68 (2004).

Keeting, Zachary, and Christopher Joy. "Carrie Moyer at CANADA." *Gorkysgranddaughter.com* (29 September 2011).

Kley, Elizabeth. "Carrie Moyer, 'Arcana.'" *Artnet.com* (20 May 2009).

Levin, Kim. "Art Listings: Carrie Moyer." *Village Voice* 48, no. 1 (1–7 January 2003).

Levi Strauss, David, and Daniel Joseph Martinez. "Teaching After the End." *Art Journal* 64, no. 3 (Fall 2005): 28–45.

Loos, Ted. "Lesbian Poster Girls: Dyke Action Machine! Founders Sue Schaffner and Carrie Moyer Talk About Their Savvy Satires of Commercial Art." *Advocate* 775 (22 December 1998): 61–62.

Lowenstein, Drew. "From Cherry Bomb to Cherry Blossom: Carrie Moyer at Canada." *Artcritical.com* (2 October 2011).

Maine, Stephen. "Addressing Liberty Without Literality." *New York Sun* (2 August 2007): 20.

———. "Carrie Moyer, CANADA." *Artillerymag.com* (October 2011).

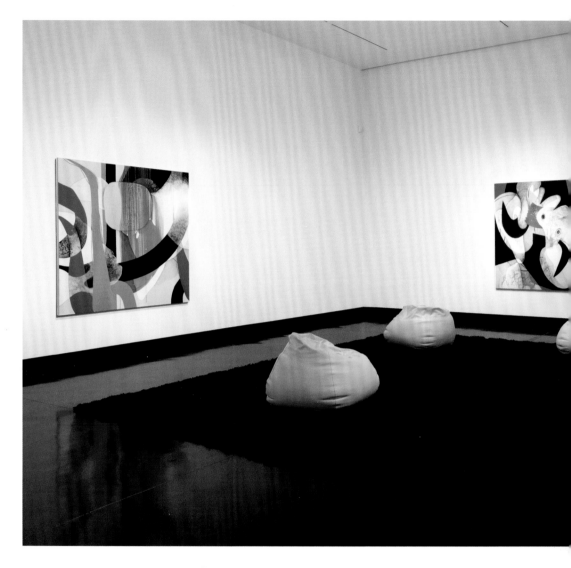

McQuaid, Cate. "'Adventures in Abstraction' at Judy Goldman Fine Art." *Boston Globe* (13 June 2003): C17.

——. "Everything Is Illuminated." *Boston Globe* (23 February 2006): H8.

——. "Galleries Without Boundaries: Step Inside (or Outside) and See the Art of Tomorrow." *Boston Globe* (7 October 1999): 12.

——. "Moyer's Arts of Seduction." *Boston Globe* (24 April 2012): G6–7.

——. "Revolution, Utopia, and Other '60s Dreamscapes." *Boston Globe* (26 January 2002): F1.

Molesworth, Helen. "Worlds Apart: Helen Molesworth on Generations of Feminism." *Artforum* 45, no. 9 (May 2007): 101–102.

Morris, Bob. "The Age of Dissonance: Mind if They Ask?" *New York Times* (1 August 2004): 3.

Mueller, Stephen. "Carrie Moyer." *Art in America* 97, no. 9 (October 2009): 166–167.

——. "Lesbian Cubism." *Gay City News* (18 January 2007).

Installation view,
Tang Museum, Saratoga
Springs, New York, 2013

Nahas, Dominique. "Carrie Moyer at Debs & Co." *Art in America* 89, no. 4 (April 2001): 141.

Nickas, Bob. "Best of 2008: Abstract Painting." *Artforum* 47, no. 4 (December 2008): 292–293.

Olson, Craig. "Freeze Frame: Thrust Projects." *Brooklyn Rail* (March 2008).

Parcellin, Paul. "Art Around Town: Carrie Moyer." *Retro-Rocket.com* (February 2002).

Parrish, Sarah. "Carrie Moyer." *Art Papers* 36, no. 3 (May 2012): 56.

Peetz, John Arthur. "Critics' Pick: Carrie Moyer." *Artforum. com* (October 2011).

Princenthal, Nancy. "The Jewel Thief: Tang Teaching Museum and Art Gallery." *Art in America* 99, no. 1 (January 2011): 121.

Raizada, Kristen. "An Interview with the Guerilla Girls, Dyke Action Machine (DAM!), and the Toxic Titties." *NWSA Journal* 19, no. 1 (Spring 2007): 39–58.

Rand, Erica. "Troubling Customs: The Issues, The Problems, The Process, The Result." *New Art Examiner* 25, no. 9 (June 1998): 11–13.

Ripo, Marisa. "Ridykeulous Gets Serious." *NY Arts Magazine* 11, no. 7/8 (July/August 2006).

Rosenberg, Karen. "Art in Review: Carrie Moyer: Arcana." *New York Times* (15 May 2009): 27.

Ruane, Medb. "Outer Limits." *Sunday Times: Culture Ireland* (15 July 2001).

Rubinstein, Raphael. "8 Painters: New Work." *Art in America* 91, no. 11 (November 2003): 130–141.

Schambelan, Elizabeth. "Carrie Moyer at CANADA." *Artforum* 50, no. 4 (December 2011): 253.

Schorr, Collier. "Poster Girls." *Artforum* 33, no. 2 (October 1994): 13.

Schwan, Gary. "Diverse Offerings of 'Two Women.'" *Palm Beach Post* (20 June 2004): 2J.

Schwendener, Martha. "Attention, Please!" *Village Voice* (22–28 July 2009): 35.

Shapiro, Carolyn. "Directed Action: The Lesbian Avengers." *High Performance* 18 (Spring/Summer 1995): 80–81.

Sheffield, Skip. "Two Women Artists, Three Small Deaths." *Delray Beach News* (25 June–1 July 2004): 13E.

Simpson, Les. "Tripping Down Memory Lane." *Time Out New York* (12 October 2000).

Sjostrom, Jan. "Two-Woman Show Depicts Hands-On Art." *Palm Beach Daily News* (18–21 July 2004).

Smith, Roberta. "Carrie Moyer: The Stone Age, New Paintings." *New York Times* (2 February 2007): E35.

——. "Caution: Angry Artists at Work." *New York Times* (27 August 2004): 23.

——. "Going Beyond Marquee Names on Museum Walls." *New York Times* (6 September 2012): AR66.

——. "Varieties of Abstraction." *New York Times* (5 August 2010): C21.

——. "'Vivid' and 'Pavers.'" *New York Times* (20 January 2011): C30.

Smyth, Cherry. "Review: Carrie Moyer and Diana Puntar." *Modern Painters* (May 2006): 115.

Stillman, Steel. "Carrie Moyer in the Studio." *Art in America* 99, no. 8 (September 2011): 120–127.

Tompkins, Betty, and Robert Witz. *Appearances*, no. 23 (Summer 1996).

Turner, Elisa. "A Nuanced Past is Transformed into the Present." *Miami Herald* (18 August 2004).

Yee, Ivette. "The Female Perspective." *South Florida Sun-Sentinel* (15 July 2004).

SELECTED WRITINGS BY CARRIE MOYER

with Sue Schaffner. *DAM! Incorporated*. New York: Printed Matter, 2008.

with Sue Schaffner. *Straight to Hell: 10 Years of Dyke Action Machine!* Exhibition catalogue. San Francisco: Yerba Buena Center for the Arts, 2002.

"Alina Szapocznikow: My American Dream." *Brooklyn Rail* (October 2010).

"Beverly McIver: Minstrels in Painterly Mode." *Gay City News* 2, no. 39 (26 September–2 October 2003).

"Bomb Specific/Minor Arcana: Carrie Moyer." *BOMB*, no. 108 (15 June 2009): 37–41.

"Carrie Moyer." In *The Studio Reader: On the Space of Artists*, edited by Mary Jane Jacob and Michelle Grabner, 166–168. Chicago: University of Chicago Press, 2010.

"Charline Von Heyl: Tweaking the Canon." *Gay City News* 2, no. 43 (23–29 October 2003).

"The Deconstructive Impulse." *Art in America* 99, no. 5 (11 May 2011): 163.

"Dissolving Categories." *Art Journal* 55, no. 4 (Winter 1996): 17, 71.

"Do You Love the Dyke In Your Face?" In *Queers In Space: Claiming the Urban Landscape*, edited by Gordon Brent Ingram, Annie-Marie Bouthillette, and Yolanda Retter, 439–446. Seattle: Bay Press, 1997.

"Do You Love the Dyke In Your Face: Lesbian Street Representation." In *Lips, Tits, Hits, Power? Popkultur und Feminismus*, edited by Annette Baldauf and Katharina Weingartner. Vienna: Folio, 1998.

"Dona Nelson." *Brooklyn Rail* (October 2006).

"Energy/Experimentation: Black Artists and Abstraction 1964–1980." *Brooklyn Rail* (June 2006).

"'Field of Color: Tantra Drawings from India' at the Drawing Center. Hindu Etchings Meant to Enlighten." *Gay City News* 4, no. 2 (13–19 January 2005).

"From Margin to Mainstream: Dyke Action Machine!, Public Art and a Recent History of Lesbian Representation." In *The Practice of Public Art*, edited by Cameron Cartiere and Shelly Willis, 193–203. New York: Routledge, 2008.

"Glitter and Doom: German Portraits from the 1920s." *Brooklyn Rail* (February 2007).

"Hard Knock Life." In *Nancy Grossman: Tough Life Diary*, edited by Ian Berry, 157–159. Saratoga Springs, New York: Tang Museum/Del Monico-Prestel, 2012.

"Jack Whitten." *Brooklyn Rail* (October 2009).

"Jo Baer." *Brooklyn Rail* (May 2007).

"Judy Glantzman: Layers of Attention." *Gay City News* 5, no. 19 (11 May 2006).

"Louise Fishman: A Restless Spirit." *Art in America* 100, no. 9 (October 2012): 128–137.

"Maria Lassnig: The Pitiless Eye." *Art in America* 97, no. 1 (January 2009): 70–75.

"Martha Rosler: Photographs That Show and Tell." *Gay City News* 3, no. 350 (9–15 December 2004).

"Minister of Culture: The Revolutionary Art of Emory Douglas." Modern Painters 19, no. 9 (November 2007): 44–46.

"Mira Schor: Momenta Art." *Modern Painters* 21, no. 5 (Summer 2009): 69.

"Pat Steir: The Majesty of Paint." *Gay City News* 4, no. 14 (7–13 April 2005).

"Peter Young: Easy Rider of Abstraction." *Art in America* 95, no. 8 (September 2007): 132–135.

"Rochelle Feinstein: Modernist at the Disco." *Art in America* 96, no. 8 (September 2008): 152–181.

"So Different, So Appealing: Carrie Moyer on the Women of Pop." *Artforum* 48, no. 8 (April 2010): 83–86.

"Stephen Mueller: Lennon, Weinberg." *Art in America* 99, no. 2 (February 2011): 100.

"Sylvia Sleigh." *Brooklyn Rail* (February 2010).

"United Society of Believers." *Cultural Politics*. 3, no. 3 (November 2007).

"Viva." *Modern Painters* 19, no. 7 (September 2007): 70–77.

"William Pope L: Engaging a Discussion of Blackness." *Gay City News* 4, no. 23 (9–15 July 2005).

ACKNOWLEDGMENTS

WHEN POLLY SINGS ABOUT the avenging Pirate Jenny in Act 1 of Brecht's Threepenny Opera, the symbolism embedded in the tale of daring rescue and violent revenge reveals a desire to break from those that hold her back. The marauding thieves offer her power, and in turn, freedom. Carrie Moyer's paintings similarly take back some of the power hoarded by art history's regulars. Hers is a kind of painting that combines careful craft with unpredictable combinations of colors and textures and a wild abandon when it comes to unusual materials, inventive technique, and surreal shapes. It is an independent practice that is inspiring at every turn and it is an honor to present her work in her largest museum show to date.

An impressive group of paintings that span the past six years was assembled including several examples from a new body of monoprints made in collaboration with Marina Ancona at 10 Grand Press. We thank Marina and all the lenders who made the exhibition possible: Kay Turner and Mary Sanger, Bryan and Tara Meehan, Yoshii Gallery, and CANADA. Special thanks to Suzanne Butler at CANADA for her assistance and especially to Carrie who generously lent several works from her studio and made new paintings for the exhibition as it traveled allowing us to realize new installations at each venue.

We are grateful to our partners at Columbus College of Art and Design and Savannah College of Art and Design where the exhibition traveled. Thanks to Michael Goodson at CCAD for his early enthusiasm and support and Laurie Ann Farrell, Isolde Brielmaier, and especially Melissa Messina at SCAD.

Thanks to the New York State Council on the Arts, the Overbrook Foundation and the Friends of the Tang for their important ongoing support of Opener exhibitions and publications. Beverly Joel designed this catalogue, with new photographs by Arthur Evans and Bill Orcutt among others. Thanks to Barry Schwabsky for his essay and Jay Rogoff and Megan Hyde for their editorial assistance.

The Tang Museum staff worked as a team in presenting this project, thanks to Jose Luis Aguirre, Ginger Ertz, Torrance Fish, Megan Hyde, Elizabeth Karp, Susi Kerr, Emily Lemieux, Karen McEachen, Jennifer Napierski, Patrick O'Rourke, Vickie Riley, Barbara Schrade, Rachel Seligman, Kelly Ward, and our installation crew, Luke Anderson, Samuel Coe, Patrick Girard, Matthew Scellen, and Cynthia Zellner. We are thankful for the dedication and important assistance from our Skidmore College student interns Rachel Aisenson '13, Madeleine Capshaw '12, Brett Hartman '13, Ayelen Pagnanelli '14, and Jenna Postler '13.

95

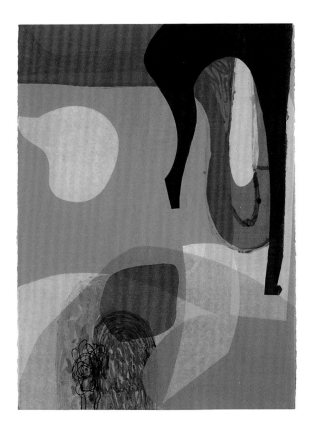

Untitled, 2012
Monotype
30 x 22 inches
Courtesy of the artist
and 10 Grand Press

Thanks to Sheila Pepe for her steadfast support and important feedback and our warmest appreciation to Carrie for her trust and spirit of collaboration that set the stage for us to experiment in the gallery to realize a unique and provocative environment for her paintings in the museum. —Ian Berry

I WOULD LIKE TO THANK the generous, first-rate staff at the Tang Museum, including Rachel Seligman, Vickie Riley and Megan Hyde. I would also like to thank CANADA Gallery, in particular Suzanne Butler for all that she does and Wallace Whitney for his long-standing support. Barry Schwabsky wrote a wonderfully dense essay that is filled with surprises and strangeness and for that I am extremely grateful. To the designer of this book, Beverly Joel, a professional high-five—brilliant job! It has been a pleasure, honor and just plain fun to work with Ian Berry on this exhibition and catalog. Over the years, Ian has assembled a singular and amazing constellation of art and artists at the Tang. I feel very fortunate to be part of it.

This is dedicated to my Painting Doctor, the One and Only Sheila Pepe.
—Carrie Moyer

This catalogue accompanies the exhibition

OPENER 24
CARRIE MOYER:
PIRATE JENNY

The Frances Young Tang Teaching Museum and Art Gallery at Skidmore College Saratoga Springs, New York January 26–May 19, 2013

Columbus College of Art and Design
Columbus, Ohio
February 6–May 1, 2014

Savannah College of Art and Design
Savannah, Georgia
June 24–October 12, 2014

The Frances Young
Tang Teaching Museum
and Art Gallery
Skidmore College
815 North Broadway
Saratoga Springs,
New York 12866
T 518 580 8080
F 518 580 5069
www.skidmore.edu/tang

State of the Arts

NYSCA

This exhibition and publication are made possible in part with public funds from the New York State Council on the Arts, a state agency, The Overbrook Foundation, and the Friends of the Tang.

ISBN: 9780982148679
Library of Congress Control Number: 2013949266

All images are copyright of the artist. Thanks to all photographers whose work is reproduced in this book including those listed below.

Cover, 34, 35, 36, 37, 54, 58–59, 62, 63, 64, 65, 66, 67, 70, 71, 76, 78–79, 80, 85, 90–91, 94: Arthur Evans
Pages 2, 4, 19, 40–41, 43, 44, 46, 51, 52, 53, 55, 56, 57, 60–61, 68–69, 72–73, 75, 86: Bill Orcutt
Pages 8, 14, 23, 26, 27, 28–29, 30, 49: Cathy Carver
Pages 11, 20, 31, 32, 33, 39: Arturo Cubria

Designed by Beverly Joel, pulp, ink.

Printed in Italy by Conti Tipocolor

Cover:
Hook, Line & Sinker, 2012 (detail)
Acrylic, graphite on canvas
72 x 60 inches
Private Collection

Page 1:
Studio collage, 2013
Paper and tape
4½ x 5¾ inches